The Campus History Series

BALDWIN-WALLACE
COLLEGE

On the cover: Over the years, Marting Hall has become a symbol of Baldwin-Wallace's rich history and beautiful campus. Nearly every modern student has enjoyed a class within its walls. Built in 1896 to house administration for German Wallace College, it was initially called Memorial Building to honor those who made its construction possible. In 1938, it was renamed in honor of John C. Marting, former graduate, outstanding treasurer, and Berea mayor. Disaster struck in 1982 when aged water pipes froze and burst, flooding Marting Hall and causing extensive damage. Talk of permanently closing the historic landmark was quelled in 1984 when an extensive fund campaign made the necessary renovations possible. Marting Hall was rededicated in 1989 and stands proudly today as an enduring reminder of Baldwin-Wallace's heritage. (Courtesy of Baldwin-Wallace archives.)

The Campus History Series

BALDWIN-WALLACE COLLEGE

MARY K. ASSAD

ARCADIA
PUBLISHING

Copyright © 2008 by Mary K. Assad
ISBN 978-0-7385-5180-7

Published by Arcadia Publishing
Charleston SC, Chicago IL, Portsmouth NH, San Francisco CA

Printed in the United States of America

Library of Congress Catalog Card Number: 2007939008

For all general information contact Arcadia Publishing at:
Telephone 843-853-2070
Fax 843-853-0044
E-mail sales@arcadiapublishing.com
For customer service and orders:
Toll-Free 1-888-313-2665

Visit us on the Internet at www.arcadiapublishing.com

This book is dedicated with love to my parents,
Kathleen M. Assad and James A. Assad,
and in memory of their fathers,
Samuel F. Cury (1922–2006) and Albert A. Assad (1917–1998).

CONTENTS

ACKNOWLEDGMENTS

Compiling this history has been a rewarding challenge. I have worked with so many wonderful people whose love of Baldwin-Wallace (B-W) inspired me even further to chronicle our college's history through pictures and words.

Abundant thanks to Judy Krutky, associate academic dean for intercultural education. Her kindness and support were instrumental in writing this book. To senior vice president Richard Fletcher and the College Relations staff, who made a personal aspiration into a college-sanctioned endeavor and supported my work before seeing the finished product. Specifically to Helen Rathburn, George Richard, Ron Linek, Kevin Ruple, Alicia Maurer, and Mary Stein. To B-W's presidential legacy—Neal Malicky, Mark Collier, Georgianna Bonds, and Richard and Karen Durst—for their enthusiastic contributions. To those who helped since the project's early days, including Bob Ebert, Stan and Beverly Maxwell, Kathy McKenna-Barber, Indira Gesink, Carol Templeman, Charlie Burke, Linda Short, and Ron Ehresman. To the English department, history department, Exponent Campus Media, and B-W Learning Center for their full backing. To the Berea Historical Society and college historian Louise Kiefer for making abundant archives accessible. To my editor at Arcadia, Melissa Basilone, for cheerful assistance throughout.

Thanks to the following B-W personnel for their correspondence, personal interviews, and moral support: Cassandra August, Louis Barone, John Basalla, Julie Bishop, Margaret Brooks-Terry, Ralph Carapellotti, Haesook Chae, Douglas Chatfield, Harold Cole, Edward Crider, Michael Dolzani, Robert Drake, Mary Ann Fruth, Sean Gabriel, Louise Gray, Terrie Grospitch, Jean Haag, Jay T. Hairston, Tiffany Hansbrough, Theodore Harakas, Lawrence Hartzell, William Kelso, Christie King-Shrefler, Nancy Larson, Wade Massad, Jim McCarger, Michael Melampy, Andrew Mickley, Jacqueline Morris, Regina Mushabac, Susan Oldrieve, Dwight Oltman, Ladonna Norris, Neal Poole, David Proctor, Pat Scanlan, George Schiller, Roy Seitz, Rong Song, Margaret Stiner, Sue Strew, Jo Swanson, Joe Tarantowski, Sabine Thomas, Marc Vincent, Bob Wallis, and Nancy Wurzel.

Thank you to the B-W archives, Berea Historical Society, College Relations archives, and individual contributions for providing the images in this book.

Thank you to my parents for supporting me since before I spoke my first word, let alone wrote my first book. To my friends for their encouragement, especially Sandra Lee, Jill Parker, Missy Barner, Kevin Risner, Adam Bowers, Shawn Gaines, Jessica Widowski, and Kristin Duffy. Thank you most of all to God for his many blessings, including my wonderful B-W experience.

Any omissions are accidental, and I truly appreciate the contributions and collaboration of everyone involved who helped me become acquainted with B-W's history. Now let the story begin.

INTRODUCTION

It's better today.
—1918 graduate, reflecting on changes at Baldwin-Wallace

Choose a morning in early February and take a stroll around the Baldwin-Wallace (B-W) campus. Linger a while on the North Quad or in front of Marting Hall. See groups of students huddled inside coats—the braver ones shivering beneath school-spirited hoodies—carrying backpacks and tote bags or balancing a cup of steaming coffee from the Cyber Café. Their shoes shuffle through piles of stunning whiteness, and an occasional snowball darts across Seminary Street aimed at a laughing target. They seem unaware of what has gone before their presence here. But you can close your eyes and rewind through a century and a half of triumphs and challenges, academics and activities, new fads and outdated fashions, friendships and courtships. Keep the month the same, shift the location slightly to the southwest, and open your eyes. The snow on this campus is marked by sleigh tracks instead of tennis shoe prints. There are fewer buildings and fewer students. The young adults trekking down the street carry firewood for their stoves instead of cases containing laptops. John Baldwin, founder of the college, lives only a short walk away. Despite the contrast, these two campuses both foster a keen-mindedness that is awakened through scientific experimentation, intellectual discussion, or the prose of a beloved author. They both promote the belief that education is an inheritable right. They both share a history.

In 1828, John Baldwin arrived in the small township of Middleburgh; he and his new bride settled on the 200-acre farm that he had purchased sight unseen. The same campus that now is notorious for its feisty squirrels was, at the time of Baldwin's arrival, territory for panthers, wildcats, turkeys, and wolves. The early 19th century was a time of American idealism, and the frontier embodied that spirit of hope. Reform movements spread like wildfire, and social experiments often took place in the west, where social institutions had yet to be established. Middleburgh typified such frontier movements, and Baldwin exemplified the utopian spirit.

By 1836, Baldwin had joined with two other devout Methodists and founded the Community of United Christians to promote God and education. Liquor and tobacco were forbidden, leisure time was limited, and a simple life was promoted. A popular story tells that the name Berea was chosen in a coin toss because of its appearance in the book of Acts, as a community of people governed by the word of God.

The utopia's founders established the Berea Seminary in March 1837 to further their religious goals. Classes at the primary level were held in a meetinghouse, and students also learned practical skills such as gardening. However, the utopian experiment only lasted until 1839, its failure the result of economic problems, organizational weaknesses, differences among its leaders, and lack of member cooperation. A historical account by former B-W professor Clyde Feuchter relates that Baldwin and his cofounders were left

"in debt and in despair to make what they could of the wreckage of their hopes and their property."

An unsuccessful utopia and its resulting debt were not enough to deter Baldwin, who believed "it is the Christian's duty both to get and give all he can." Devoting his time to prayer and reflection, he did not give up hope, and his optimism did not go unfulfilled.

The means for overcoming the financial difficulties lay in the great stratum of sandstone stretching across Ohio and coming closest to the surface in Berea. Baldwin happened to discover a fine-grained stone on his property. Around 1838, he invented a method for the stones to be turned upon a lathe, leading to the production of grindstones and a revolution in the construction industry. His gratefulness to God for the discovery of "Berea Grit" inspired a lifelong devotion to the cause of religious education and missionary work.

As Baldwin's industriousness launched an era of Berea quarrying, Josiah Holbrook, the founder of America's great lyceum movement, visited Berea in 1838 and established the Lyceum Village. The Berea Lyceum School offered both primary and secondary education to "encompass and enlighten the whole world." However, like the utopian society, the Berea Lyceum School was short-lived. Yet again, Baldwin's perseverance, practical mind, and strong faith did not accommodate failure. When his circumstances allowed him to properly fund another venture, Baldwin established the institute bearing his name on December 20, 1845. The seminary was affiliated with the Methodist Church, and the Ohio Conference soon chose a board of trustees. The first building was constructed in the spring of 1846; it was formally known as North Hall but familiarly referred to as "Old Muley." Rooms cost just $2 per quarter. At this time, the school grounds were still surrounded by wilderness, and students helped to clear the territory.

Strict bylaws were established to maintain discipline and keep students focused on their work. For example, nine hours each day were spent on study and recitation. Drinking, and even frequenting locations that sold liquor, was prohibited. Men and women could not take walks together, nor could they be seen speaking with one another in the school halls. Regular church attendance was required, and lights out occurred nightly at 10:00.

In July 1855, John Wheeler became principal of Baldwin Institute, but plans were already set in motion to transform the preparatory school into a university. By this time, public schools had mostly replaced academies as the main vehicle of education. Thus, the Berea school could not feasibly exist for much longer unless it expanded to include higher education. Practicality aside, Baldwin and other leaders recognized that expansion would further promote the Methodist Church and religious education among the population. The final piece of the puzzle, which made the adjustment possible, came from one of the institute's trustees. James Wallace, another Berea quarry owner, pledged to finance the construction of a new building for the school if college-level courses were added and if an endowment would be obtained for the new department. Wheeler agreed to these terms. In 1856, a charter was granted to transform the school into a university, with a preparatory department attached. Thus, Baldwin University was born, and higher education would soon supplant the school's original focus.

Expansion was now the primary goal. In August 1858, a German department was created to serve the increasing German immigrant population. This program flourished, and on June 3, 1863, a resolution was passed to establish the department as a separate school. So began German Wallace College, dedicated to the promotion of "scientific education and Biblical Christianity, especially among the Germans in America." All classes were taught in German, and the school attracted both wealthy and poor students.

For many decades, Berea boasted two colleges, with a common heritage and Methodist affiliation, whose classes were open to students from either college. Financial circumstances

and practical considerations led to the amalgamation of Baldwin University and German Wallace College in 1913, with the union giving rise to B-W as we know it today.

Throughout the 20th century, B-W has responded to the evolving American society most often by anticipating and pioneering change. Baldwin's devotion to inclusiveness and his enlightened worldview were truly novel at this time. Baldwin, whose mother was denied entrance to Yale because of her gender, pledged to provide education for anyone regardless of race, nationality, creed, wealth, or gender. Baldwin University was among the earliest U.S. colleges to offer coed instruction. Baldwin also was involved in the establishment of colleges in Kansas, Louisiana, and Bangalore, India. The early days in Middleburgh left a mark on Baldwin; after all, the lyceum movement set out to educate the world, and certainly Baldwin held fast to this mission his entire life. B-W has maintained its founder's ideals through the years and applied them to modern circumstances, with inclusiveness and global outreach consistently at the forefront of the school's agenda.

Former B-W president Neal Malicky shared with me the memory of an alumni meeting he attended in California some years ago. In the front row sat Clarence Ellinger, a 1918 B-W graduate who would live to be 101 years old. At the meeting, when asked to compare the modern B-W to its earliest days, Ellinger thoughtfully and succinctly replied, "It's better today." Those three words, so simply expressed, represent one of the most fundamental goals of B-W—continual improvement. While honoring our history, we must consistently build upon the foundations established by our forbearers. We should never be content with the status quo but instead must recognize and meet new frontiers that continue to arise.

Generations of leaders at B-W have invested years—in some cases lifetimes—in a college that defied failure and overcame many challenges since its establishment. And now the 21st century presents a new frontier full of unique obstacles. Current B-W president Richard Durst believes that we must adhere to the fundamental values of our heritage while progressing to the brink and looking over the edge to see what is out there, using that knowledge to shape our new surroundings. We must plan, build, and achieve so that another Clarence Ellinger will say, decades from now, that B-W is "better today." This insistence upon continual improvement is the best way to honor our history.

The current-day student, taking notes in a Wheeler Hall (1891) classroom or eating lunch in the Lang (1928) dining hall, may take a moment every now and then to reflect upon B-W's history. A statue or plaque engraved with facts from the past may catch one's glance, or the architecture of Dietsch Hall might spark curiosity. But rarely does he or she have the opportunity to delve deeper and uncover the true heritage that stands in our midst. How do we even begin an acquaintance with the people and events that shaped an enduring and prominent institute of higher learning? And going one step further, how do we begin to share those stories?

While carefully perusing a biographical sketch or scanning the words of a crumbling newspaper, I cannot help but envision a snowfall of the kind so infamous in Greater Cleveland. The snow keeps falling and falling, accumulating to our knees and weighing upon the tree branches. Each snowflake is unique to itself yet perfected even more through its unity with the rest. This is how I can best explain B-W's history. Each person, event, achievement, and anecdote is a snowflake, and the snow keeps falling as each new day is added to the past. One stroll through the snow will not uncover every frosty prism that completes the scenery. Likewise, one book surely cannot tell all the stories worth relating. But it can endeavor to share a few and pique interest in many more. It can begin to tell B-W's story simply by making a start.

There is a beautiful layer of snow blanketing Berea, and if you take a walk in early February—or any time—you can see it, right where it has been since 1845.

One

A CONSECRATED EDUCATION

It is altogether fitting and proper that we keep in mind and revere the memory of the founder of this school. . . . These facilities are largely the result of the generosity of others, and the very term "generosity" implies some degree of self-deprivation on the part of the giver. We are the beneficiaries of the sacrifice of others.
—John Baldwin Jr., honoring his father

John Baldwin was a man of deep convictions. His vision for bettering the world enabled the establishment and enduring legacy of Baldwin-Wallace College (B-W). As a student, Baldwin chopped firewood and did other chores to fund his education. Wealthy students taunted him, but Baldwin ignored their cruel remarks. Knowing the importance of an education for serving God, Baldwin was determined to establish Christian institutions for boys and girls to obtain "a consecrated education." Baldwin believed that anyone who desired an education should receive one, regardless of race, gender, ethnicity, or wealth. This man and these tenets form the foundation of B-W.

Until 1913, two schools of higher learning operated in Berea, enjoying common roots and a cooperative relationship. By 1895, Baldwin University offered degrees in science, literature, philosophy, law, and the arts. Music departments were established at both colleges and were later merged to form the conservatory. The Nast Theological Seminary was founded at German Wallace College in 1899 to educate Methodist ministers.

Rigid social protocol limited student activities until the 1880s, when restrictions were lightened, and young men and women enjoyed events such as sleigh rides and serenades together. On one occasion, a faculty-sanctioned "challenge squirrel hunt" took place between the junior and senior men; the seniors lost and cooked supper for the juniors. In the 1890s, the bicycle craze hit Berea, leading to the formation of Wheel Clubs.

Beginning in 1888, due to encroaching quarries, the Baldwin University campus was gradually moved from its original location between the east shore of Baldwin Lake and South Rocky River Drive to a 20-acre parcel at Front Street and Bagley Road. Two original buildings—Ladies Hall and Hulet Hall—were dismantled and rebuilt on the new site, which exists today as B-W's north campus.

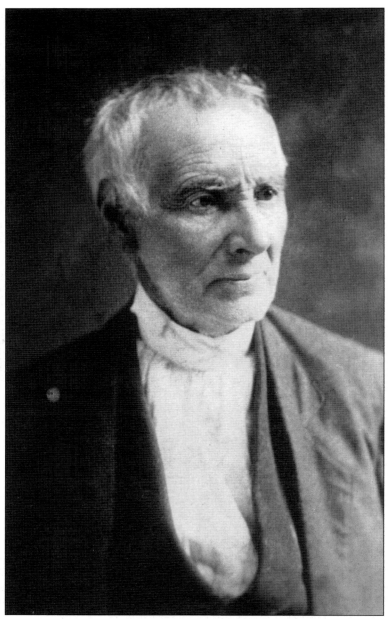

On Founder's Day 1952, B-W president John L. Knight gave a tribute to John Baldwin Sr. that captures the essence of Berea's most revered citizen. "Here was a man who would not surrender to difficulties, hardships, failures, or reverses. And he had his full share of all those. Here was a practical, common man; yet a man of tremendous energy and of remarkable ingenuity. He espoused good causes with a zeal and an earnestness which were irresistible. It was his determination and persistence, as well as his money, which built B-W. He fearlessly opposed slavery, and his home was part of the Ohio Underground of the Civil War era. He was frugal in his living, yet generous in his giving. Not without odd mannerisms and idiosyncrasies, he nonetheless possessed those stone-like qualities of personality and high purpose which made him a leader of men. He was affectionately known as 'Father Baldwin.'"

The generosity of James Wallace contributed to the establishment of Baldwin University, and Berea has been known for its excellence in higher education ever since. In 1858, he funded the construction of Wallace Hall, which was later given to German Wallace College and became the school's first administration building. It was torn down after the construction of Marting Hall in 1896.

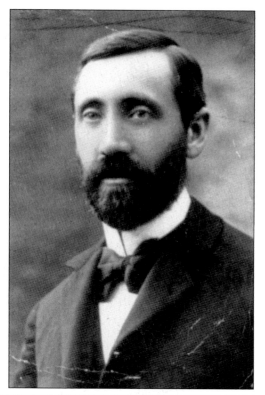

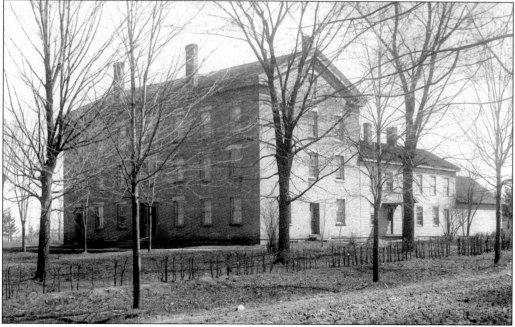

South Hall was Baldwin University's first residence for women. It was built around 1849, deemed unsafe for use by the 1890s, and destroyed by fire on May 31, 1899, in an event some folks speculated to be arson. While in use, the hall contained two floors of living space, a dining room, and a natural science recitation room.

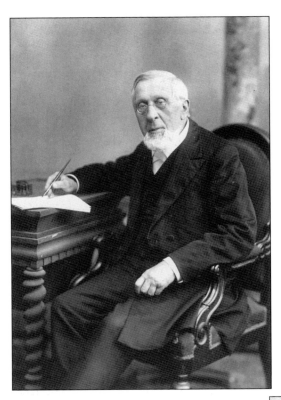

Dr. William Nast was the first president of German Wallace College (1864–1894). Called the "Father of German Methodism in America," he held many leadership roles in the church. John C. Marting said of him, "It seemed as if no evil thought found lodging in his heart. He was always ascribing all the mercies and the victories to God. The blessed Christ seemed to be uppermost, at all times, in his thoughts."

Jacob Rothweiler, the first vice president of German Wallace College, was a pioneer of education among German Methodists. He worked as a preacher and missionary before visiting Berea in 1855, when he suggested that a German department be established at the college and planted the seeds for a second college in Berea. Jacob Street is named for him because at one time he owned land in that area.

Mary D. Baldwin, wife of John Baldwin Sr., is pictured here in 1883. When North Hall was built in 1846 to house Baldwin Institute men, the kind-hearted woman fed the workers at her own table. The workers also slept at the Baldwin home, dubbed the "Old Red House." Years later, the Baldwins established their home as an Underground Railroad station, the first in the township.

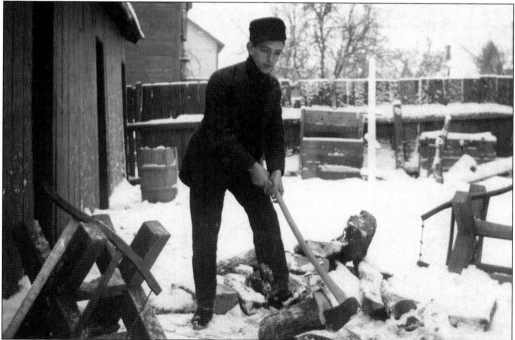

In the early years, students had stoves in their dormitory rooms to keep warm during the winter months. Before 1900, young men were responsible for chopping their own firewood.

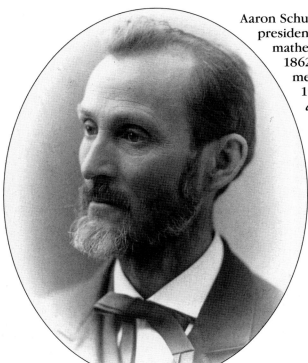

Aaron Schuyler served as Baldwin University's president from 1875 to 1885. He had been a mathematics professor at the college since 1862 and was known for his informal methods of teaching. Schuyler wrote 15 books, among them *Empirical and Rational Psychology*. This book was published in 1882, years before William James wrote the groundbreaking *Principles of Psychology* (1890).

Joseph Stubbs served as president of Baldwin University from 1886 to 1894. The major event associated with his term is the sale of the quarry land and the subsequent relocation of the college to its new location. Among other previous jobs, Stubbs had served as vice president of Ashland College from 1880 to 1882.

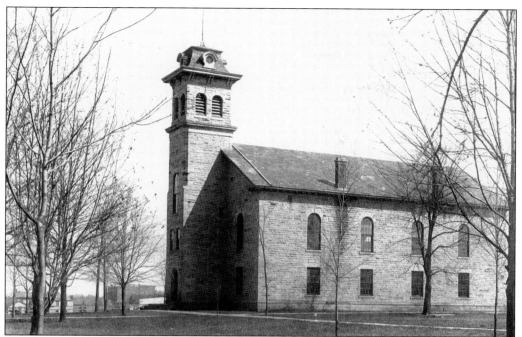

Hulet Hall was a gift to Baldwin University by one of its trustees, Fletcher Hulet. He was also a quarry owner, and the building was comprised of sandstone from his own property. Work began in 1859 but was halted during the Civil War when Hulet defended Ohio during Morgan's Raid. The building was completed in 1868, and the tower was added later. The *Cleveland Press* reported in 1894, "The hall is an extensive stone structure and it is stated that much of its material was quarried and cut by Hulet's own hands. Moonlight [*sic*] nights frequently found him hard at work so anxious was he to finish the gift." Hulet Hall contained a recitation room on the first floor and a chapel on the second floor and was located on the old Baldwin University campus. Students are pictured on Hulet's steps below.

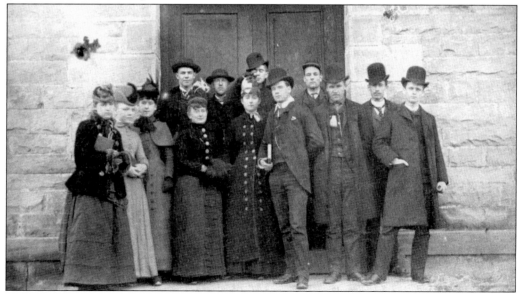

Elisha Loomis was so precise in his ways that he even wrote his own obituary, with spaces left for his age and date of death. Loomis graduated from Baldwin University in 1880 and is pictured as a young man at left. He became chair of mathematics at Baldwin University in 1885, where he stayed for 10 years. Loomis was an avid writer; his many works included a biography of Aaron Schuyler and an 800-page genealogy of Joseph Loomis (his pioneer ancestor). At age 88, he wrote *The Pythagorean Proposition*, which included 367 proofs of the theory. This surpassed the previous record of 108 completed by a Washington lawyer. Despite these achievements, his obituary read, "Of all honors conferred upon him he prized the title of 'Teacher' more than any other." Loomis is pictured below with his calculus students in 1894 (bottom right).

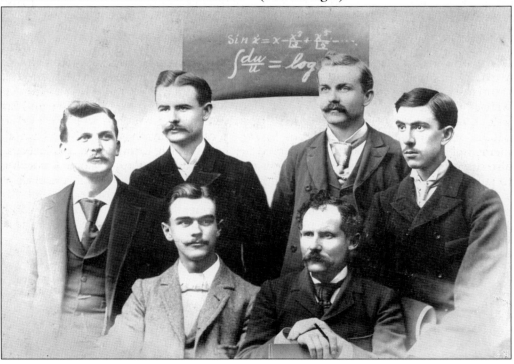

Karl Riemenschneider (fourth from left) sits with Baldwin University's bachelor of arts students in 1889. Born in 1844 in Kentucky, Riemenschneider was educated in Germany while his father, a pastor, did missionary work there. His arrival at German Wallace College in 1868 was the start of nearly 50 years of service to B-W. He and his wife, Amelia Smith, were married for 55 years and had five children who survived to adulthood, including Albert, who is best known for establishing the annual Bach Festival. Riemenschneider, a professor who mastered German, English, Latin, Greek, and Hebrew, also served as vice president and later president of German Wallace College. According to student recollections, he thoroughly enjoyed holding a first-year Hebrew class at 5:15 a.m. He received offers from schools such as Harvard and Yale, but he felt his place was in Berea, and that is where he stayed. Former student T. L. McKean recalled, "Dr. Riemenschneider had only kindness and patience for those who did their best, whatever that best might be."

John Baldwin Jr. and Lury Gould Baldwin were married for 57 years. John graduated with the first Baldwin University class, of five students, in 1859. Lury graduated in 1861. They both were dedicated to the educational principles of John's father. Upon Lury's death in 1923, a memorandum issued by the B-W faculty described her as "a continuing friend, a loyal supporter who, with her husband, did what her hand found to do, and did it well and gladly."

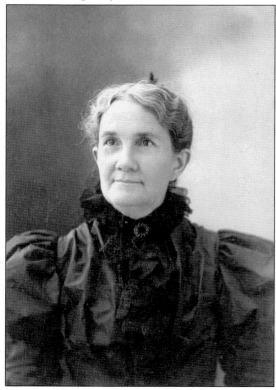

Philura Gould Baldwin (right) is known as B-W's first librarian. She was born on November 28, 1865, and graduated from Baldwin University in 1886. She established a library in the basement of Hulet Hall, using books from various literary societies. Tragically, her life was cut short by tuberculosis on March 3, 1892. As a tribute, her parents built the Philura Gould Baldwin Memorial Library and asked for one simple payment: the White Rose Ceremony. Each commencement, 26 ladies are chosen from among the senior class, one for each year of Philura's life. They take part in a ceremony that includes an oration by a chosen speaker, songs, and the presentation of a rose before Philura's picture in the library. The single white rose symbolizes youth, purity, and virginity. The photograph below depicts Philura with her father, John Baldwin Jr.

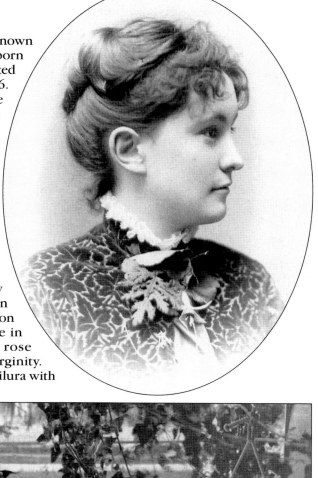

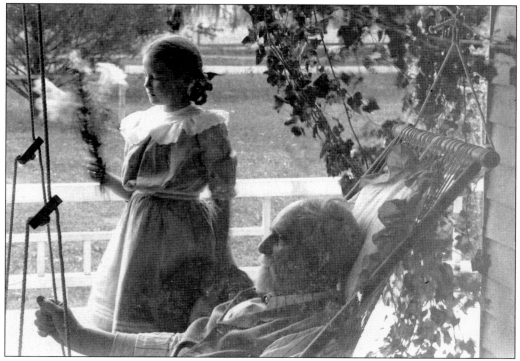

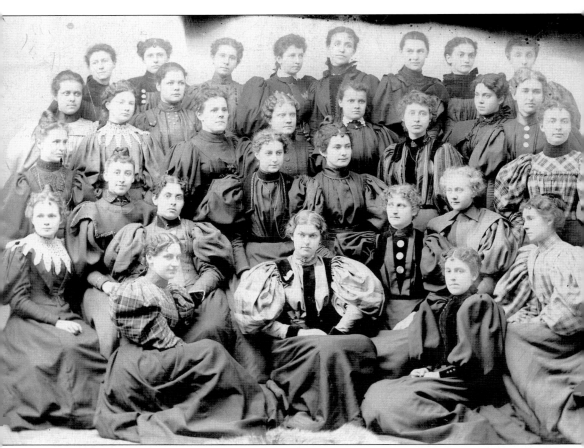

Literary societies were the forerunners of sororities and fraternities. The first society to appear in Berea was the General Library Lyceum of Baldwin Institute, formed in 1849. The group of men and women met weekly to improve their literary expression and appreciation. In 1852, the society became male only when the women decided to leave, and the men renamed their group the Philolothian Society. However, the young ladies formed the Alethean Society in 1855, and from that point on, each of Baldwin University's literary societies contained either men or women but not both. The ladies pictured here belonged to the Alethean Society of 1895–1896. This organization, like others of its kind, operated under very strict bylaws. Fines were imposed for even small infractions, such as missing meetings without a reasonable excuse or whispering during prayer. The Alethean Society is the direct ancestor to Alpha Gamma Delta, the first sorority established at B-W in 1940.

John C. Marting, known as "Pap Marting," devoted his life to God at age 15. He served as B-W treasurer for 45 years, beginning at German Wallace College in 1895. That same year, the groundbreaking for Memorial Hall (below) took place; the building would be renamed in Marting's honor in 1938. During Marting's term as treasurer, B-W's endowment increased from $100,000 to nearly $2 million. Meanwhile, Marting worked as a Methodist minister for 64 years, served as mayor of Berea for two terms, and held numerous other leadership posts. Campaigns against bootlegging and gambling earned him the name "Crusading Mayor." In Marting's final days, he is remembered as saying, "I am so thankful to God that we need not put off preparing for eternal life until we are sick, but can have the assurance of life eternal all through life."

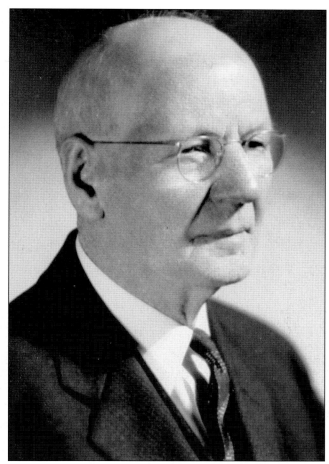

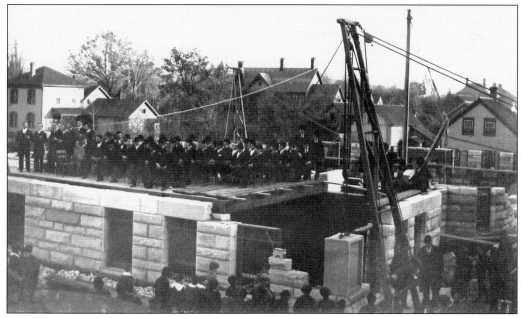

Known by students as "Pap Schneider," Peter F. Schneider converted to Methodism at age 14 when missionaries came to his father's home. He became a preacher in 1848 and served as vice president and financial agent of German Wallace College from 1873 until his death in 1895. Kind and warm, Schneider made friends wherever he went. On his dying bed, he said, "Great joy I have not, but a strong trust in God."

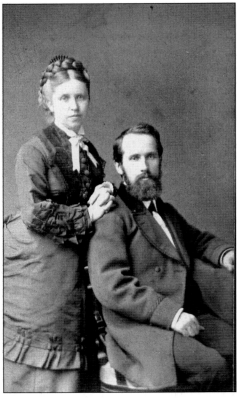

C. F. Paulus was an outstanding teacher at German Wallace College during the late 19th century. He worked as a preacher, professor, author, and composer of hymns and was incredibly devoted to the success of the college. He is pictured here with his wife, in what may have been their wedding photograph.

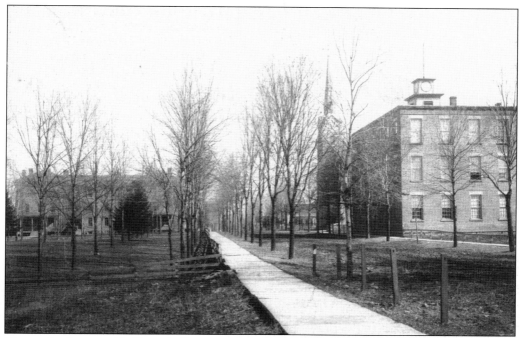

The early German Wallace College campus can be seen here, prior to the construction of Memorial (Marting) Hall behind Wallace Hall (far right), with the latter being torn down in 1896. This view faces north, and Seminary Street now replaces the walkway. Kohler Hall, the oldest existing building on campus, can be seen behind the trees (far left). The College Chapel (formerly the German Methodist Episcopal Church) is visible as well.

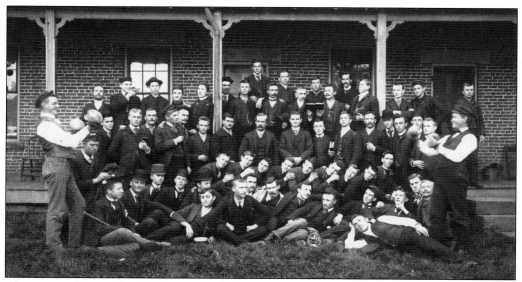

German Wallace College students gather in front of the men's dormitory in 1892. Known today as Kohler Hall, the building has undergone constant remodeling and additions over the years. Initially home to children of the German Methodist Orphan Asylum, it was sold to the college around 1867. Since then it has housed faculty and students and also served as the barracks for the Student Army Training Corps during World War I.

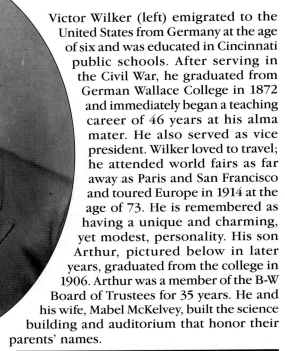

Victor Wilker (left) emigrated to the United States from Germany at the age of six and was educated in Cincinnati public schools. After serving in the Civil War, he graduated from German Wallace College in 1872 and immediately began a teaching career of 46 years at his alma mater. He also served as vice president. Wilker loved to travel; he attended world fairs as far away as Paris and San Francisco and toured Europe in 1914 at the age of 73. He is remembered as having a unique and charming, yet modest, personality. His son Arthur, pictured below in later years, graduated from the college in 1906. Arthur was a member of the B-W Board of Trustees for 35 years. He and his wife, Mabel McKelvey, built the science building and auditorium that honor their parents' names.

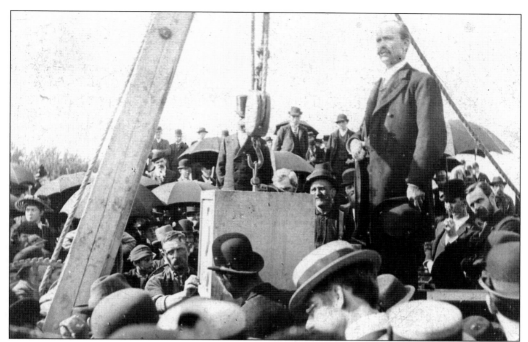

On October 10, 1891, the cornerstone was laid for Recitation Hall, the first newly constructed building on the Baldwin University campus. Mary Baldwin helped with the ceremony, and her son John Baldwin Jr. was present as well. The Romanesque building was constructed of Berea stone, and its interior contained woodwork of red oak and Georgia pine. Amenities like heating and electricity were a modern touch. From 1904 to 1927, the building was the site of an interesting yearly tradition. Each graduating class gathered around the hall to have the last two digits of its year carved on a brick around the wainscot, about six feet above the ground. The numerals are still visible to this day. In 1915, Recitation Hall was renamed Wheeler Hall (in its finished form below) in honor of John Wheeler, the first president of Baldwin University.

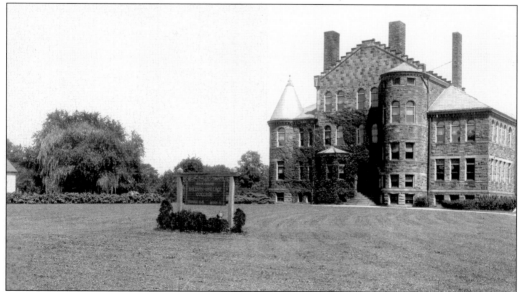

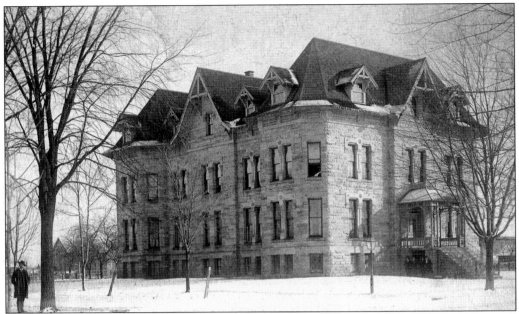

Appearances can be deceiving, but these photographs depict two separate buildings in two different locations. Ladies Hall (above) was built in 1882 to house the women of Baldwin University. It was located on the original campus, and when the college relocated, Ladies Hall had to be moved. A financial grant from Andrew Carnegie funded the operation, with the agreement that the newly built structure would house science classes. Beginning in September 1905, Ladies Hall was dismantled stone by stone and reassembled at the corner of Front Street and Bagley Road. John Paul Baldwin, grandson of the school's founder, oversaw the dismantling and reconstruction. Each stone was marked to ensure a correct duplication of Ladies Hall. The only change was in the location of the door. The building was newly christened as Carnegie Hall (below) and exists as part of the Malicky Center today.

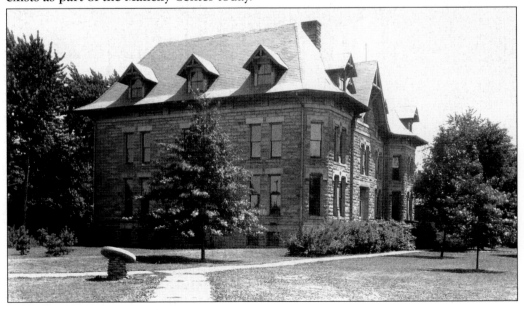

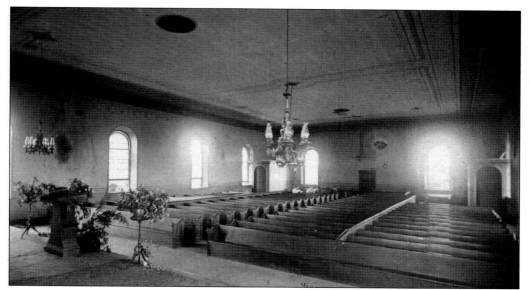

Baldwin University's chapel, located on the old Hulet Hall's second floor, was also used for commencement day ceremonies and lectures. Many acclaimed lecturers from across the United States came to Berea to speak in Hulet during the late 19th century.

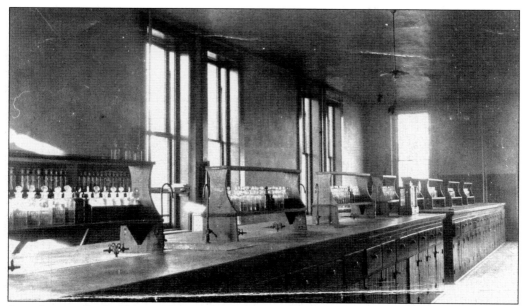

Seen here is the freshman chemical laboratory in Carnegie Hall. Fortunately for science majors, modernized versions of the room are available today elsewhere on campus.

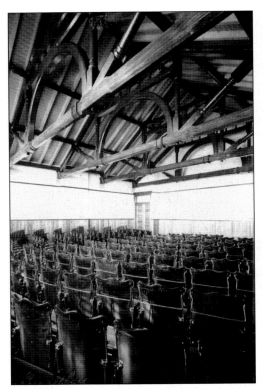

The chapel on the third floor of Recitation (Wheeler) Hall is seen here. The prominent ceiling was covered when the area was no longer used as a chapel. However, renovations in the 1990s uncovered the original ceiling, which is now visible as part of the education department's classroom space.

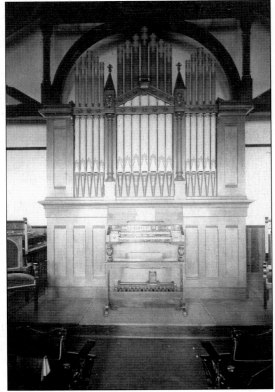

Pictured here is Berea's first pipe organ, which was installed in Baldwin University's "new chapel," as Wheeler Hall's third floor was then denoted.

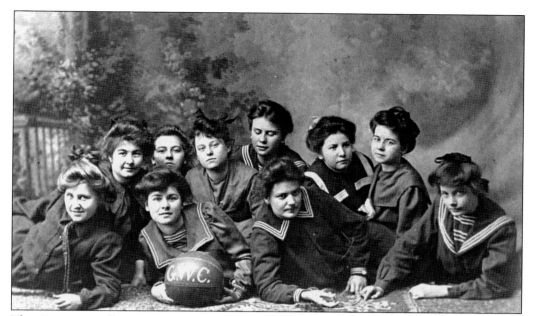

The German Wallace College ladies' basketball team is pictured here in 1903. In 1922, the Department of Physical Education for Women adopted a point system for athletics, a landmark achievement. The athletic board awarded letter sweaters to deserving girls beginning in the 1922–1923 school year.

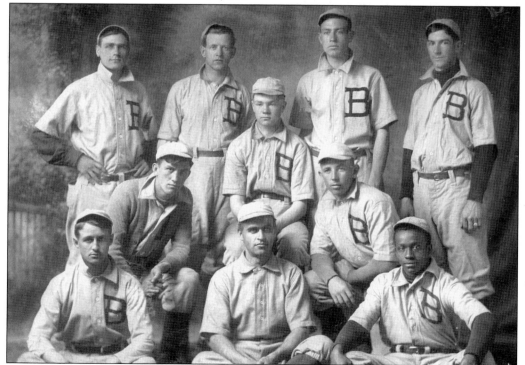

Baldwin University's 1909 baseball team was distinguished for more than its actions on the field. It included the first African American in the history of B-W athletics, Ed J. Cargill (front row, far right).

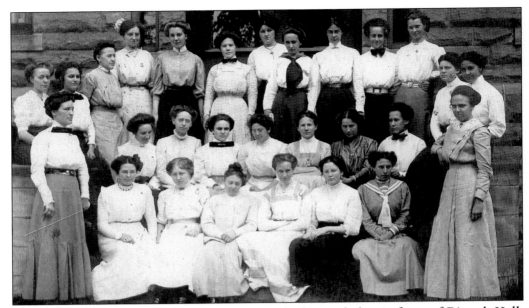

This 1910 postcard (which cost just 1¢ to send) depicts ladies in front of Dietsch Hall, which houses the foreign language department today. The structure was built in 1899 thanks to a generous gift by Michael and Lydia Ann Dietsch. They believed God wanted them to sell their farm and finance the construction of a much-needed ladies' dormitory for German Wallace College. Early residents of "Dietsch Castle" enjoyed modern conveniences for as little as 75¢ per week.

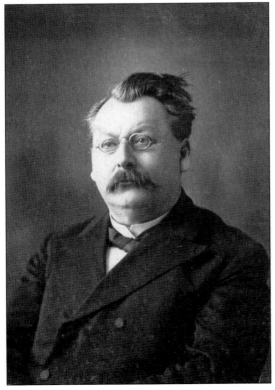

Julius O. Berr was an extremely talented professor, but his reputation was not completely academic. His family lived behind Dietsch Hall. Their water pump, hidden by grapevines, was a favorite meeting place of couples, including 1911 graduate Walter Lemke and his girlfriend. Lemke recalled, "The Berrs knew young love when they saw it and were most kind to us, [and] Mrs. Berr often baked an extra pie or cake for the boys in the dorm."

Long tables filled the German Wallace College dining hall, located in the basement of the men's dormitory (Kohler Hall). Both men and women dined here. In accordance with a popular custom, the men would line up outside the building upon completion of their meals and wait to escort their girlfriends across the street to Dietsch Hall. Sometimes a sneaky boy would offer his arm to someone else's lady, causing rivalry among the lads.

Ever wonder what dormitory rooms looked like a century ago? This image, captured by student photographer Walter Lemke, gives a glimpse inside a men's dormitory room around 1911.

Are these young men, seated outside Recitation (Wheeler) Hall, serious scholars or playful pranksters? The November 1, 1906, edition of the *Plain Dealer* reported that a cow, stolen from Ora Usher's barn on Bagley Road, was released into Recitation's third-floor chapel. Upon its discovery, the animal was blindfolded and backed down two flights of stairs into open air.

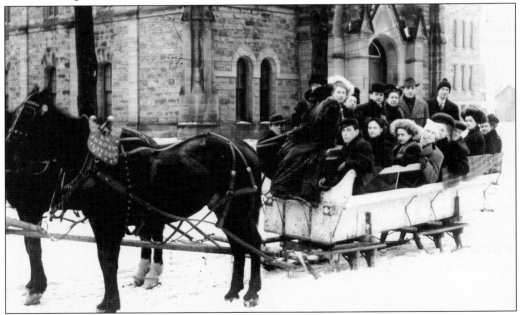

Coed sleigh riding was banned until the 1880s, although the young men and women found ways around the rule. This photograph was taken when the activity was legal, in 1910. A few years later, a headline from the campus newspaper, the *Exponent*, would read, "Eighty college students, Good Sledding, Three Sleds, 'Eats'—What More is Needed for Good Time." Would modern students agree?

Two

A UNITED MISSION

A peculiar responsibility rests upon the educated man or woman.
The opportunity of the school has been afforded them that they may be better
fitted for social service. They are custodians of knowledge and presumably
of wisdom. Theirs is a spiritual trusteeship.

—Pres. Albert Storms, 1925

For a half century, two colleges called Berea home. However, by 1912, Baldwin University was suffering from financial problems while German Wallace College was expanding. A union of the two schools with common roots was the best solution, and the merger took place on August 26, 1913, giving birth to B-W as it stands today. Arthur Breslich, the president of German Wallace College, became president of the united B-W, and Baldwin University's president, Glezen Reeder, became vice president. A new era had begun.

By the time of the merger, German instruction was no longer necessary; most students were second-generation Americans. As the language barrier decreased, so did social rigidity. The literary societies of the former century soon evolved into fraternities and sororities. The Schiller Society was transformed into Lambda Chi Alpha, the first Greek letter fraternity at B-W, in 1926. Alpha Gamma Delta was the first campus sorority, forming in 1940 with the Alethean literary society as its ancestor.

Soon after the 1913 merger, Albert Riemenschneider united the music schools of the formerly separate colleges to establish the B-W Conservatory of Music. Two decades later, he and his wife founded the Bach Festival, which exists today as the oldest collegiate Bach celebration in the country.

Despite these accomplishments, the early years of B-W were not without their challenges. As the Great Depression wreaked its devastation, B-W experienced financial turmoil in the 1930s. In March 1943, college president Louis Wright anticipated that the school would close the following autumn. However, just one month later, the U.S. government announced the V-12 program, and navy men arrived in Berea by June to begin their education. This cooperative venture between the U.S. military and private colleges across the country gave many schools the enrollment boost they needed, and it rescued B-W in particular from demise.

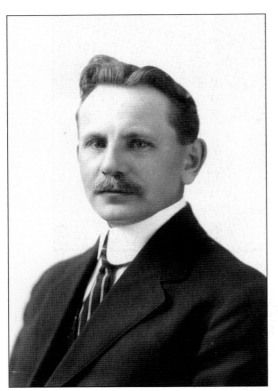

Arthur Breslich graduated from German Wallace College in 1898, served as the school's president, and then became B-W's first president in 1913. Heated controversy arose in 1917 when he wanted "Silent Night" sung in German at the yearly Christmas service. Because of Germany's role in World War I, a huge backlash arose. Marches and petitions called his patriotism into question, and he was removed from office. Breslich wrote B-W's original alma mater.

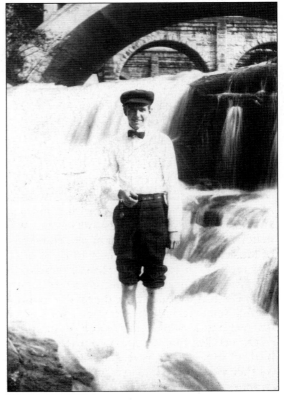

Herbert Tubbesing, B-W class of 1917, is seen here by "the Rocks," located along the east branch of the Rocky River and still extant today. The Rocks, a romantic site for couples, was also a popular destination for springtime trips, when students would enjoy a college-sanctioned day off from classes. The 1917 yearbook reveals that Tubbesing was "on the Dietsch Hall eligible list, a rare distinction, gained by few."

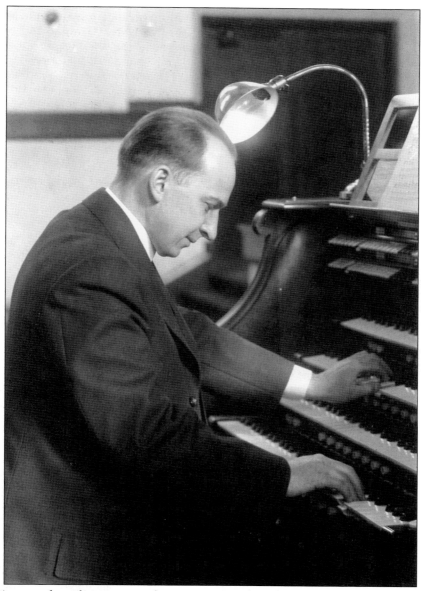

Albert Riemenschneider was a teacher, musician, administrator, author, composer, editor, and scholar. He graduated from German Wallace College in 1899 and served his alma mater until 1950 as professor of piano and organ, director of the German Wallace School of Music, founder and director of the Conservatory of Music, and acting president of B-W in 1949. He established the conservatory in 1913 by uniting the music schools of the merging schools. In 1933, he and his wife, Selma Marting Riemenschneider, founded the Bach Festival, an annual tradition that continues to be one of B-W's most distinguished events. Selma wrote a biography of her husband in 1963, in which she described Albert's delicate physical condition as a child; people often commented to his mother that the lad might not live long. However, young Albert compensated by enthusiastically involving himself in athletics, and as the rest of his life proved, the inquiries addressed to his mother were of little consequence. The man's strength of mind and character live on through his family legacy and Bach tradition.

On June 4, 1914, the first commencement of B-W took place. Students received diplomas from the following courses of study: normal, music, science, and arts. The class also included postgraduates and law school students. Ernest Guenther, pictured here, was an arts course graduate whose senior research project was entitled "The Realization of the Social Message of Christ." Such capstone projects were required of students at the time.

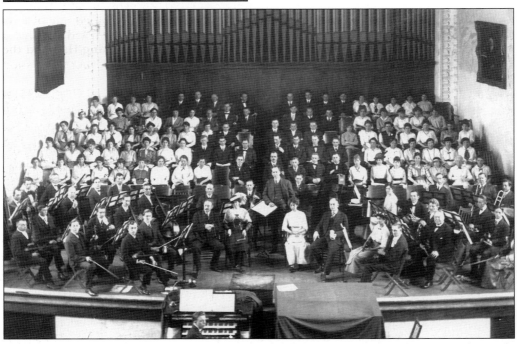

This photograph, taken in 1915, features the choral union and orchestra in the early days of the conservatory. The Austin pipe organ, installed the previous year by Albert Riemenschneider, stands prominent. The ensemble is gathered in the music building and auditorium, which would be renovated and renamed Kulas in 1939.

World War I soldiers stand tall and proud, although most likely their expressions conceal nervousness about their impending call to duty. Their young faces remind one of wars throughout the ages; specifically at B-W, students have consistently been active in major conflicts since the Civil War. Below, a rally takes place outside Marting Hall and the chapel. One sign reads, "Make Baldwin-Wallace safe for democracy," echoing the mission of Woodrow Wilson and marking a critical moment in U.S. history.

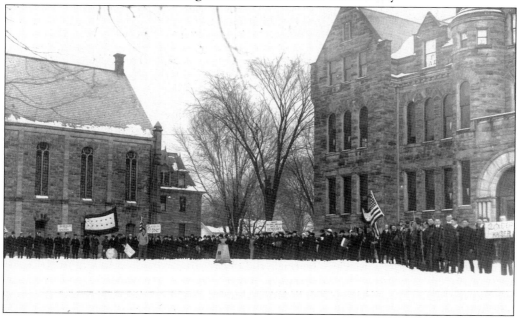

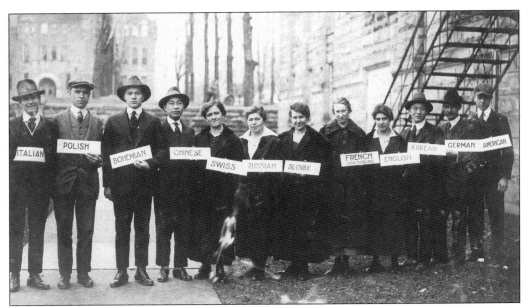

This photograph depicts the diverse group of foreign students at B-W in 1917. The Berea colleges had admitted international students since before 1900, and large influxes occurred after both of the world wars. In 1949, scholarships were established for international students, and a committee was created to help the students with any problems or needs during their stay in Berea.

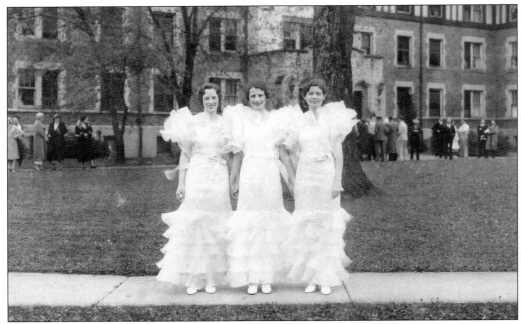

The first May Day celebration was held at B-W on May 22, 1920, and soon became a yearly festivity featuring dancing, singing, and a parade on Front Street. This image is from the 1930s; the lady in the center, Jane Devery Wyrme, was chosen as May queen. In 1999, the springtime celebrations were moved to April to accommodate the calendar switch from quarters to semesters, and April Reign was born.

Albert Storms became president of B-W in 1918, ending the discord of the Breslich era. He served the college until his death in 1933. Born in 1860, on the eve of the Civil War, Storms lived through some of the most tumultuous periods in U.S. history. Perhaps because of this, he continuously planned development programs and looked ahead to B-W's future, even through difficult times. During his tenure, B-W became fully accredited, also winning membership in the Association of American Universities and the American Association of University Women. Storms's powerful and timely baccalaureate sermons were highly anticipated and made statements concerning a college's duty to society. In his 1925 sermon, Storms said, "A passion for truth and a passion for knowledge in every realm of interest where great principles struggle for expression, must characterize the modern college, or it bears incriminating evidence of having lost its birthright."

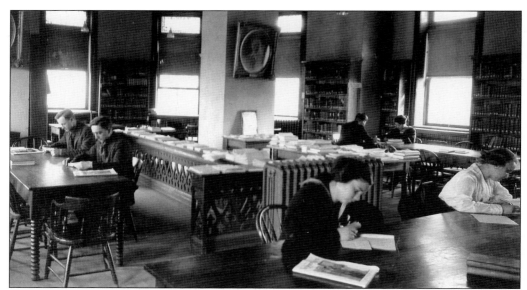

Philura Gould Baldwin is known for saying, "I find my chief interest in living in the wonderful thoughts of great writers. I must read and find the broader something in literature." She would have been happy to see students working diligently in the library built in her honor. The reading room is pictured here in 1922.

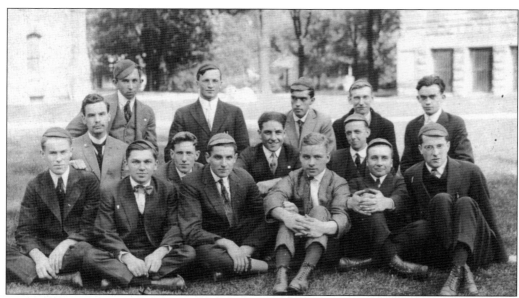

This group of B-W freshmen, dating from around 1930, shows the freshmen caps that were so infamous at the college for decades. New students had to don these beanies during their first semester on campus and were required to tip their hats to upperclassmen they passed on the street. The cap wearers also had to open doors for faculty and upperclassmen.

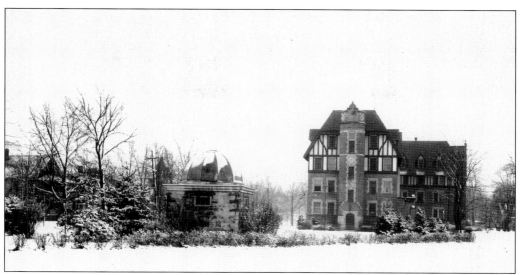

The photograph above depicts Emma Lang Hall in its early days, beside the Smith Observatory. Lang Hall was dedicated in 1928 as a dormitory for women, capable of housing 130 ladies. The basement contained a cafeteria and dining hall (below). The dormitory was named in honor of Emma Stocker Lang, a B-W alumna and wife of a college trustee. She was a successful business owner and active participant in Methodist and philanthropic affairs. Both the residence hall and dining hall exist today, although the landscape of the north campus has undoubtedly changed. Smith Observatory, a small domed sandstone structure, was built in 1922 and housed modest astronomy equipment. The building was replaced by the Burrell Memorial Observatory in 1940 when increasing class sizes necessitated a larger learning space.

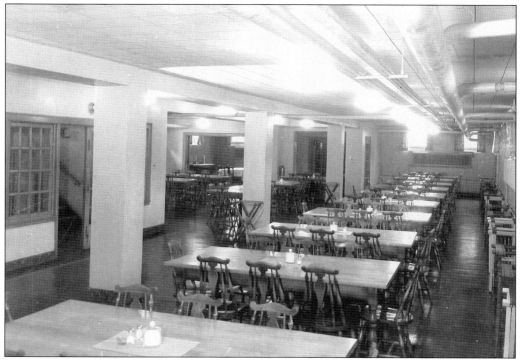

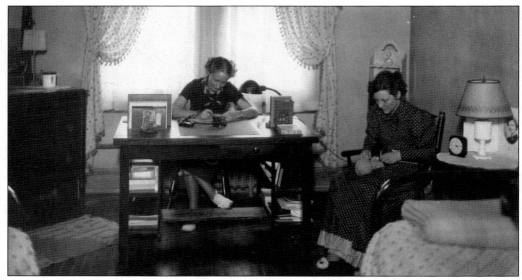

If these ladies had access to the Internet, their away messages would probably read, "Letter writing" or "Crafting." However, these young women attended college in the 1930s, and their background noise while relaxing consisted of the breeze against the window instead of the hum of a computer fan. This photograph was most likely taken in Lang Hall.

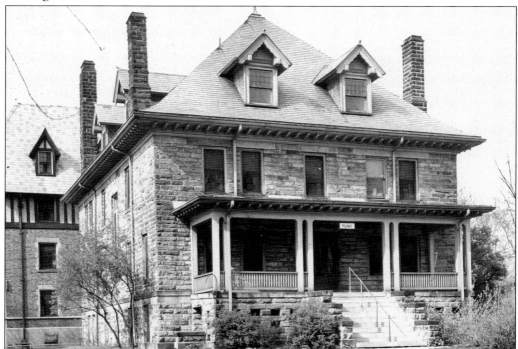

Ladies Hall was not the only building salvaged during the campus move. Hulet Hall was also dismantled brick by brick, and the component parts were used to construct a new Hulet, seen here. The structure took on a different use, as a residence hall for women, and was located in the present-day Ritter parking lot. Lang Hall is visible in the background. Hulet, in need of major repair, was torn down in 1972.

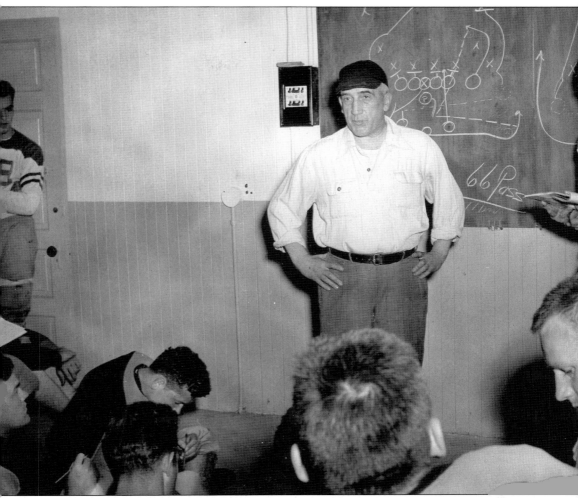

This man, talking strategy with his players during halftime, was known as "Mr. B-W." He was respected and admired by all who knew him. He left a mark on B-W that will always remain. His name was Ray E. Watts, and he began his remarkable career at B-W in 1928 when he became director of the Yellow Jackets' athletic program. He also coached football through the 1948 season, basketball through the 1958 season, and baseball for eight seasons. Watts was known for his tough discipline, fairness, and genuine concern for his players. During the 1958 winter homecoming celebration, a 30th anniversary service was held to honor Watts and his decades of commitment to B-W. Over 100 of his former players wrote letters, which were given to Watts in a book. One of these letters expressed, "I only hope that I can contribute a fraction of the guidance, example, and understanding to my boys as you have given to all of us—your boys."

Louis C. Wright, president of B-W from 1934 to 1948, was an excellent spokesman of the college who strengthened community ties. Before coming to B-W, he served as pastor of the Epworth-Euclid Methodist Church in Cleveland. Wright earned respect throughout Cleveland for his Christian influence and faithful leadership. In his 1938 baccalaureate address, he said, "There are not two ways for a man, or for mankind, to live. We know there is a God's way of life that leads to success. And we must go that way. The gate is narrow. The way is hard. But it is forever the way of life." Wright is pictured below with his wife, enjoying outdoor Bach Festival ceremonies.

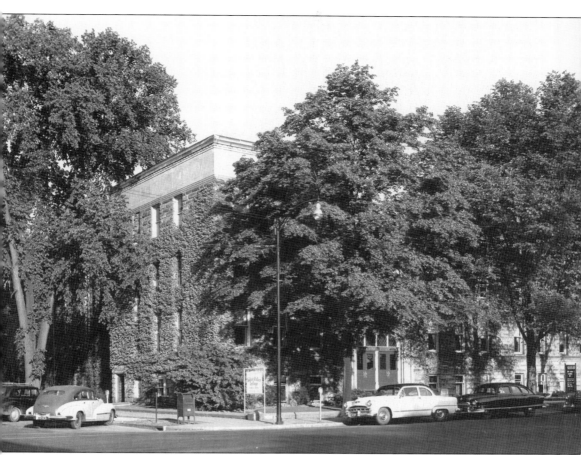

Kulas Musical Arts Building was not known as such until 1939, when it was renovated thanks to a generous gift from the Kulas family of Cleveland. The remodeling project made the structure into one of the best music education buildings in the country. The music building, as Kulas was initially called, was dedicated in June 1913, two months before B-W was united. It was built on land donated by the citizens of Berea. Classes and practice rooms, previously in Marting Hall, were moved to the new structure. The building also contained an auditorium named in honor of Fanny Nast Gamble, the first female graduate of German Wallace College. She was the daughter of William Nast. Renovations of Kulas would continue throughout the 20th century.

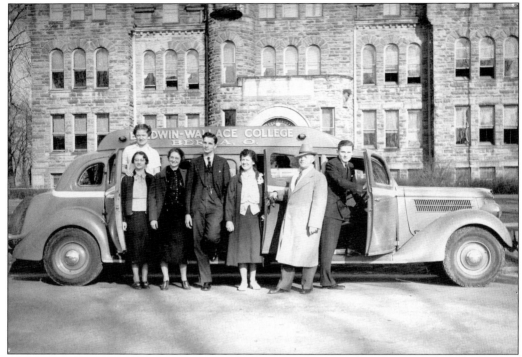

The B-W bus seen here cruised the campus streets long before today's signature vans made their appearance. This photograph was taken around 1939 in front of Marting Hall.

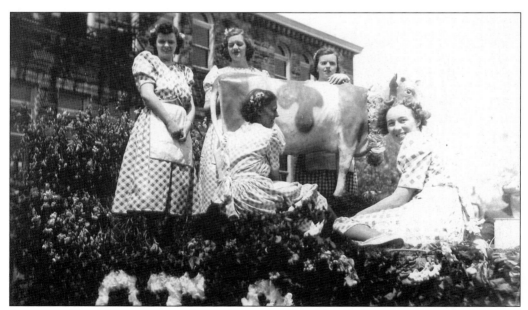

Berea students' fascination with cows continued well into the 20th century. Theta Tau Delta girls built their May Day float around a cow (although it does not appear to be a real one). Here they are seen happily parading their rurally inspired creation for the annual springtime festivities around 1940. Theta Tau Delta, a local sorority in the 1930s, organized as a national chapter in 1942 and was henceforth known as Phi Mu.

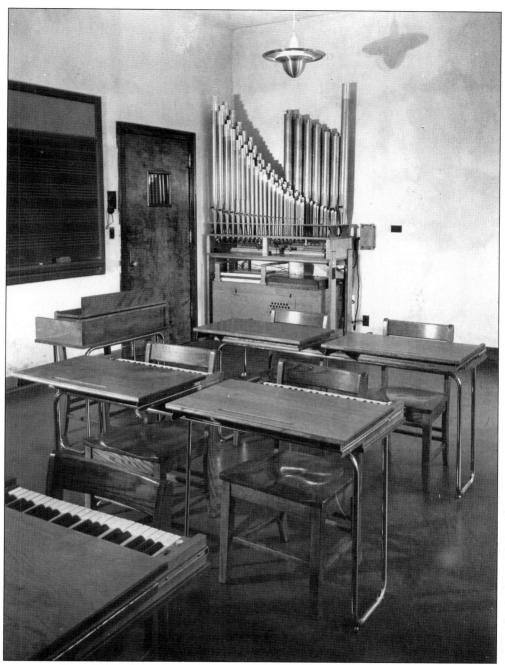

Carlton Bullis, chair of the music theory department from 1925 to 1952, created this keyboard room in the early 1940s. It contained 16 student stations and a teacher's station and was designed around a pipe organ (visible in the photograph). Lawrence Hartzell, music theory chair from 1974 to 2006, used the room as a B-W student in the 1960s and later when he returned to teach. He recalls, "Dr. Bullis was a very creative individual who was very much ahead of his time in many areas. The room was a prototype for the electronic piano keyboard rooms of today." Hartzell began an electronic music program at B-W during the 1980s and developed the MIDI-Multimedia Computer Lab.

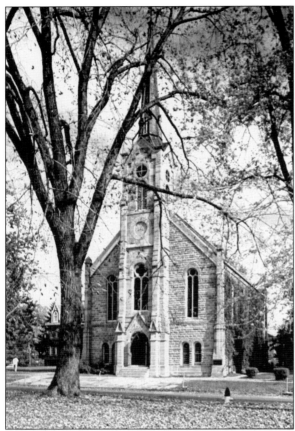

Emmanuel Methodist Episcopal Church was built in 1870 to serve the colleges and community. When a larger space was needed for the congregation in 1949, the church was turned over to B-W. Following renovations in the 1950s, it was renamed Lindsay-Crossman Chapel in honor of former B-W trustees. It remains today as a center of campus religious life and also a popular site for weddings, especially among B-W alumni.

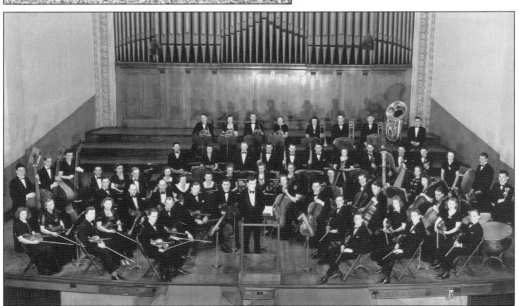

The conservatory orchestra is seen here in the early 1940s, with George Poinar as conductor. Poinar was especially interested in the music of Johann Sebastian Bach, and he traveled extensively throughout Europe to visit notable Bach sites and concerts.

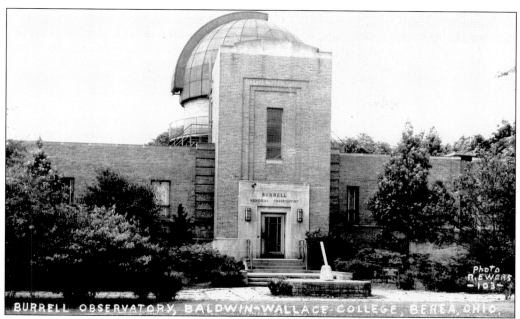

BURRELL OBSERVATORY, BALDWIN-WALLACE COLLEGE, BEREA, OHIO.

Photo R. EWERS -103-

This postcard shows the Burrell Memorial Observatory, built in 1940. Its construction was made possible through a generous gift from Katherine Ward Burrell, in memory of her husband. Edward Burrell was an exceptionally skilled engineer and worked for the Warner and Swasey Company of Cleveland for 37 years. Burrell's telescope designs were among the most ingenious of their time, and his creations were used throughout the country as well as in British Columbia. The observatory's dome, which is visible on the postcard, contains a Warner and Swasey refracting telescope (seen at right) designed specially for its home at B-W.

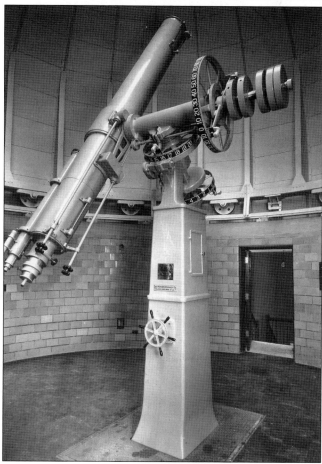

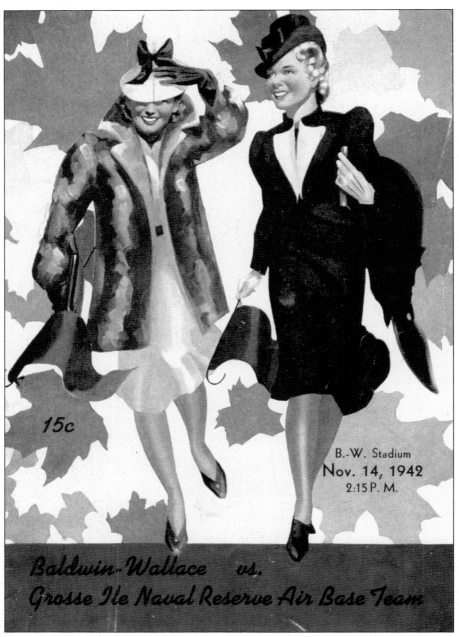

15c

B.-W. Stadium
Nov. 14, 1942
2:15 P. M.

Baldwin-Wallace vs.
Grosse Ile Naval Reserve Air Base Team

"Drop toil and worry from time to time and enter into the spirit of play, athletic sport, and the fellowship of a happy crowd. It will do us all good." These words are part of college president Louis C. Wright's welcome message contained within this sports program. The football contest between the B-W team and the Gross Ile Naval Reserve Air Base team on November 14, 1942, was a diversion for the college during the tense war years. A glimpse inside the program reveals, in addition to the president's message and other football-related information, some interesting advertisements. A half-page display for Coca-Cola promotes the "Real Thing" for just 5¢ a bottle. The May Company claims to offer "Correct Clothes for College Men," which includes corduroy slacks for $4.95. An advertisement for U.S. war bonds can be found inside as well.

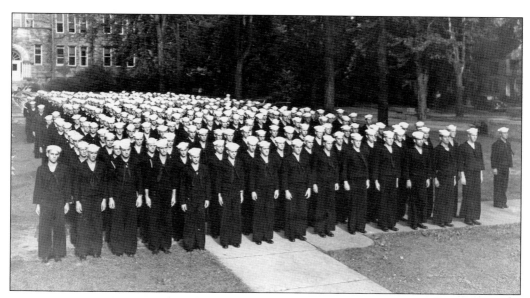

On July 1, 1943, the American government launched the V-12 program; it was a partnership between the U.S. Navy and 131 colleges and universities across the country and was the largest navy officer training program of World War II. On-campus training programs combined educational instruction with active duty. This allowed young men to attend college while serving their country and was crucial for obtaining well-trained officers in the U.S. Navy and Marine Corps. A V-12 unit of approximately 300 men was established at B-W; the servicemen lived in Merner-Pfeiffer, Kohler, and Hulet Halls, as well as the Alpha Tau Omega house. The men were received with warmth and appreciation at B-W and throughout the community. When a fire hit downtown Berea in October 1943, the V-12s manned the hoses and patrolled the area overnight to prevent looting.

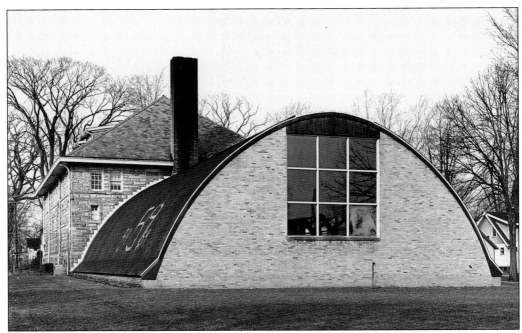

The U.S. Navy built this Quonset hut (containing a swimming pool) for use during the V-12 program. The five-lane indoor pool ranged in depth from 4 to 11 feet, and it continued to be used on campus for decades after the war. The hut and pool were removed in 2002; the space currently contains the Circle of Warmth, a bonfire area and gathering place given to B-W by the class of 2006. The photograph below depicts the synchronized swimming that was popular on campus during the years of the pool's existence.

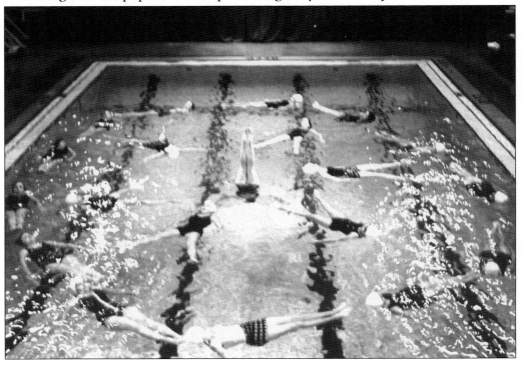

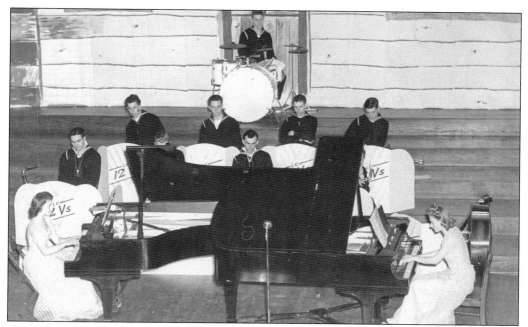

Despite a full schedule of academics and rigorous physical training, the V-12 men still found time for recreation while at B-W. They performed in variety shows along with other B-W students, like the one seen here in Kulas Hall. A band often accompanied the skits.

Wartime conditions forced B-W to hold classes on Thanksgiving Day in 1944. However, food services made the day memorable with a delicious dinner. Students of the time recalled how special it felt to have this meal prepared while away from home during tense times.

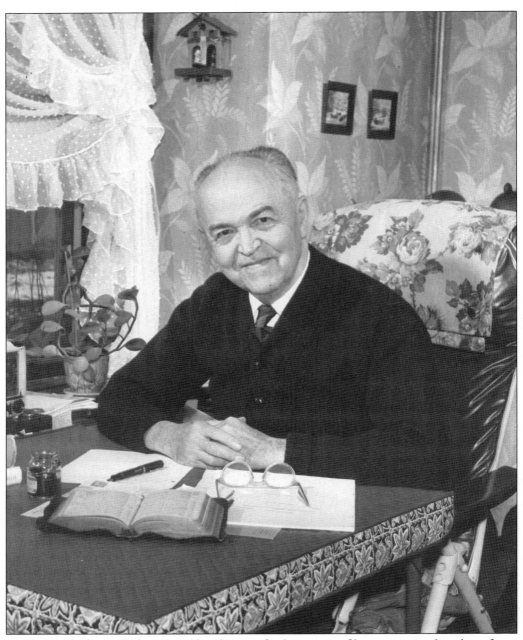

Frederick Roehm, a beloved teacher known for his sense of humor, served as dean from 1920 to 1946. Born in Germany in 1878, he was the 7th of 13 children. When he came to America at the age of 15, he knew no English, so he was placed in a class of first graders. However, he learned quickly and in a few months was advanced to high school status. He then earned his bachelor of arts degree from German Wallace College and worked as a teacher and principal before coming to B-W. In his "Advice to Freshmen," Roehm stated, "Those studies that give you a sense of relation to the fellow men around you and to the men who have lived before you are the most useful. In this day of international proximity, one to the other, it is not enough to know how the other half lives, but how the other half thinks." A middle school in Berea is named in honor of Roehm.

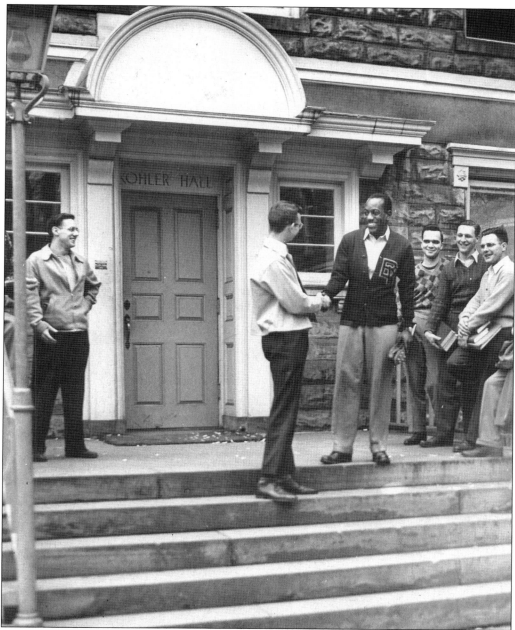

Harrison Dillard, wearing his B-W letter sweater, greets students outside Kohler Hall. While a student at B-W, he was a member of Pi Lambda Phi fraternity. The alumnus is world-famous for his Olympic titles, having won a total of four gold medals (for sprinting and hurdling) in the 1948 and 1952 competitions. Dillard was coached at B-W by the great Eddie Finnigan, whose influence combined with Dillard's stunning athleticism took the track star to the top of the sports world. Jack Clowser of the *Cleveland Press* wrote the following tribute to Dillard: "Beneath these golden threads / There beat a champion's heart, / Driving the spikes that etched / the lanes to victory's mart. / Gentleman, student, friend, / He taught us all to heed — / A man's a man for what he does, / No matter race or creed."

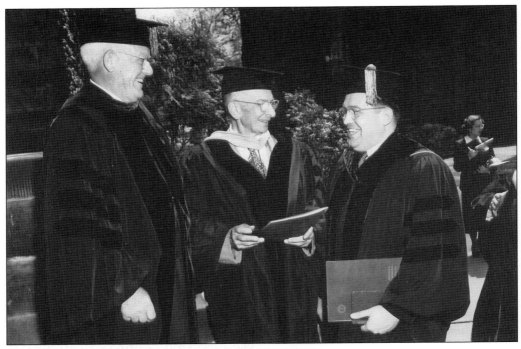

John L. Knight was inaugurated as president of B-W on May 12, 1950. He is pictured at the ceremonies with his predecessors Louis Wright (left) and Albert Riemenschneider (center), who had served as acting president during the 1948–1949 school year. Knight was one of the youngest college presidents in the country, but his ambition was no less than anyone else's. A notable achievement of his term was the Chapel Square Memorial Garden, built to honor B-W troops who died in war. Knight defrayed the cost by utilizing volunteer student and faculty labor. He resigned in 1954 to become pastor of a Methodist church in Columbus. In the photograph at left, he demonstrates one advantage of his youth.

Ted Theodore, seen here as a B-W student, graduated in 1951. He was a top athlete, stayed involved with sports throughout the years, and served as an Olympic torch bearer in 2002. Today he is among the most active alumni of the college. He served as director of planned giving and alumni director, followed by part-time work in the development office. He received the Alumni Merit Award in 2006.

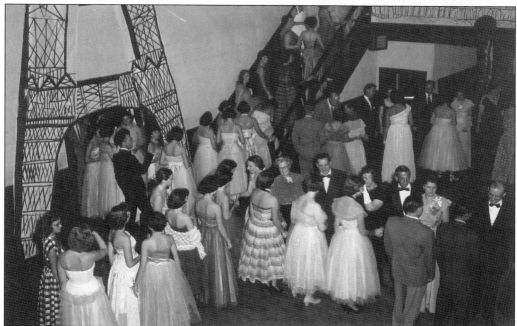

The Pump Handle was a formal reception and dance for new students, given by faculty and staff during orientation week. College historian Louise Kiefer recalls that the entire faculty would stand in a line, waiting to greet the students. The first faculty member would introduce each student to the second faculty member, and this system of introductions would continue down the entire line. This photograph dates from around 1950.

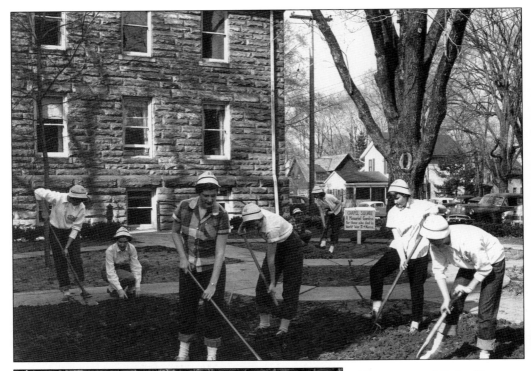

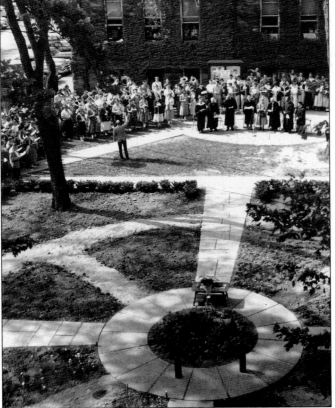

The sisters of Delta Zeta are seen tilling soil for the Chapel Square Memorial Garden during the spring of 1954. The site was located between Marting Hall and Dietsch Hall, where the present-day rose garden can be found. The memorial was dedicated in 1955, with the stately ceremony depicted here. A stone erected on the grounds stated the purpose of the garden: "Honoring the men and women of Baldwin-Wallace College who gave their lives in the service of their country."

Three

THE BONDS ERA

On the holy ground of our heritage let us, in brotherhood,
sustain our commitment to seek a nobler life for all mankind.
—Pres. Alfred B. Bonds

"Tell me about President Bonds," the author asked Robert Ebert, who has been an economics professor at B-W since 1967. Without a moment's hesitation, he answered, "For 25 years, when people thought of B-W, they thought of A. B. Bonds."

Alfred B. (A. B.) Bonds served as president from 1955 until 1981, propelling the college to new levels of success. The man who had never before administered a college pledged to raise money, and he did. Under his administration, the campus gained a number of new buildings and increased both its endowment and enrollment.

The 1970s were difficult years for B-W. Financial problems again hit hard, and college morale was low. Despite these challenges, the Bonds era is characterized by achievements that enabled B-W to rebound and continue building.

The Report of the President's Commission on Mission, chaired by vice president for academic affairs (VPAA) Neal Malicky, identified several areas of potential new program development for the college to explore. The Mission Action Project, chaired by chaplain Mark Collier (who succeeded Malicky as president in 1999), was formed to help implement the recommendations. Some outcomes included the weekend college, one of the first in the nation, in 1978; the master of business administration and master of arts in education programs; and the development of preprofessional degrees. The assessment of prior learning program was attractive to adult learners, providing an opportunity to earn college credit for previous work endeavors, in a variety of academic disciplines.

Campus life also flourished. B-W's student senate was formed in 1965. The Riemenschneider Bach Institute was founded in 1969. From 1970 to 1971, B-W hosted a blue-ribbon panel to assess campus race relations and modes of improvement. In 1975, Prof. Theodore Harakas (English) and Prof. Andrew Talton (French) inaugurated the Humanities Year program, from which modern study abroad programs have grown. In 1978, the football team claimed the Division III national championship under Lee Tressel.

The impact and pride of these achievements still resound in the 21st century.

A. B. Bonds was inaugurated on April 26, 1957. He served in the navy during World War II, held several prominent posts under Harry Truman, and served as an educational ambassador in Egypt. He literally brought a world of experience to his presidency at B-W. He commissioned his friend Felix De Weldon (most famous for his Iwo Jima sculptures) to design bas reliefs of philosophers through the ages, which adorn the walls of the Strosacker union. Yet despite a lifetime of accomplishments, Bonds is also remembered for his attention to each individual he encountered and his concern for humanity. He endeavored to make students comfortable while at B-W. His wife, Georgianna, remembers that students submitted their favorite recipes from home, to be prepared in the cafeterias. Particularly popular meals would become regularly served menu items. Robert Wallis, science professor at B-W from 1962 to 2000, recalls, "Dr. Bonds was very friendly, very outgoing. He had a car with license plates BW-1913 and he used to pick up students and drive them around campus." This tradition of personalized education has continued ever since.

Fred Harris served as VPAA and dean from 1957 to 1969. He had previously worked as an education consultant and specialist in Afghanistan and Egypt. He focused on raising academic standards and strengthening the faculty. He also worked to increase enrollment and promoted B-W along the East Coast. As a result, many students from Pennsylvania, New Jersey, and New York came to Berea for their education.

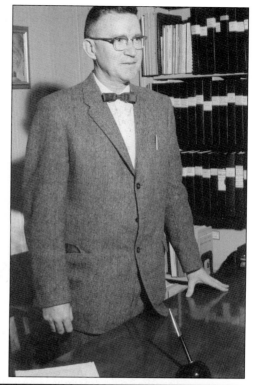

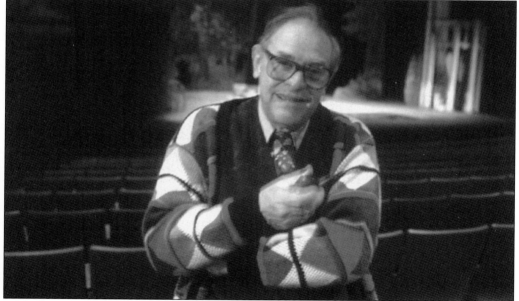

Bill Allman, seen here in later years, was among the key developers of the modern theater program in the 1950s. "Bill was a character," colleague Neal Poole says with a chuckle, recalling how Allman would recruit students by randomly approaching them and asking, "Have you ever been on stage before?" Allman started the Berea Summer Theater program in 1957, giving students and community members a chance to perform alongside noted professionals.

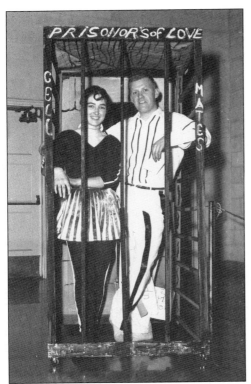

College dances were banned in Berea until the 1930s, but once the restrictions were removed, subsequent generations at B-W have made up for lost time. These photographs are from Mardi Gras dances of the 1950s. Costume contests inspired students to get creative, as seen by the "Prisoners of Love cell mates." Mickey Mouse and Minnie Mouse, better known around campus as Rob Sekinger and Martha Farmheim, stole the spotlight with a romantic moment at the 1955 function.

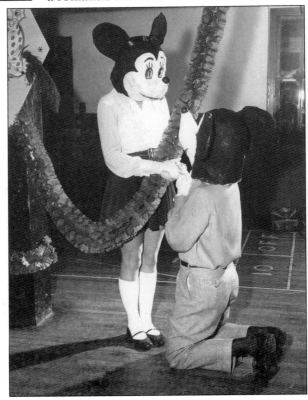

Georgia "Jo" Koontz Swanson, far right, decorates a tree with friends. Georgia met her husband, Allan, while they were B-W students in the 1950s. Georgia laughingly recalls that they met in current art history professor Harold Cole's office, which at the time was a religion classroom. Allan would later serve as continuing education director for 32 years, while Georgia would become the first female chair of faculty in the 1980s.

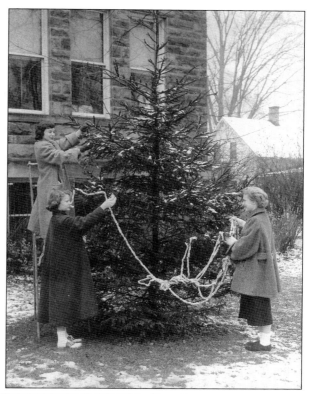

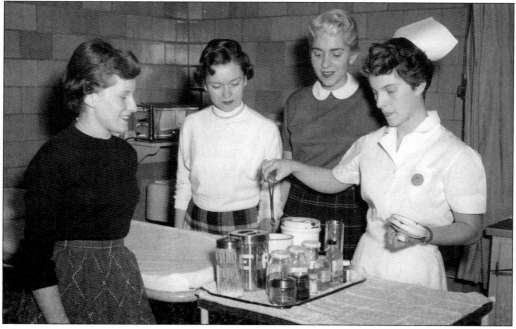

The training session seen here in 1955 was part of B-W's affiliation with Fairview Park Hospital. An agreement between the college and hospital provided nursing training for students, with classes conveniently held at B-W. These students—Rosemary Masek, Mildred King, and Kathryn Loucks—are studying with nurse Johanna Holztrager.

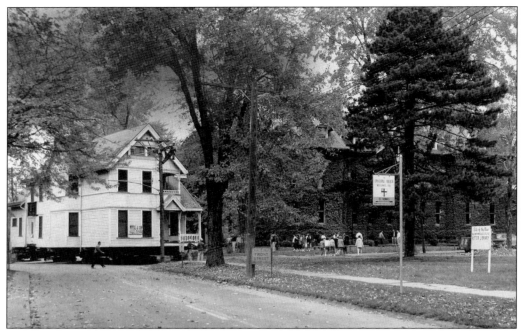

Before construction of Ritter Library began in 1957, the Home Management House had to be moved to make room. The house, seen making its way down Bagley Road, had existed since 1914 and was used for the home economics program. Rotations of girls occupied the home and practiced their domestic skills. Construction of Ritter Library is seen below in April 1958, with Lang Hall and Hulet Hall (no longer existing) visible in the background. The library's construction was funded by friend and alumni donations, including an initial gift from George Ritter, a 1906 graduate of Baldwin University.

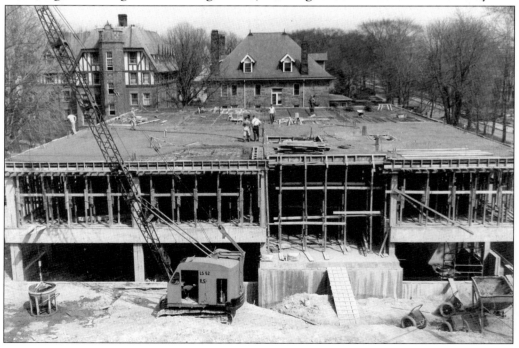

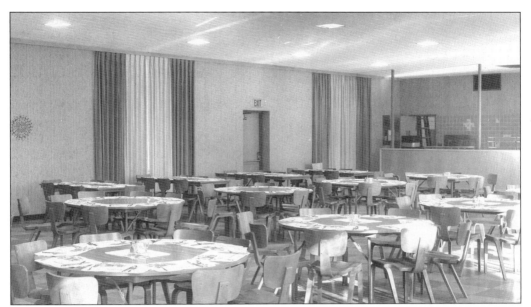

Findley Hall opened as a dormitory in 1957, and its dining hall is seen here. Today this area, instead of serving hungry students, functions as the dormitory's recreation room.

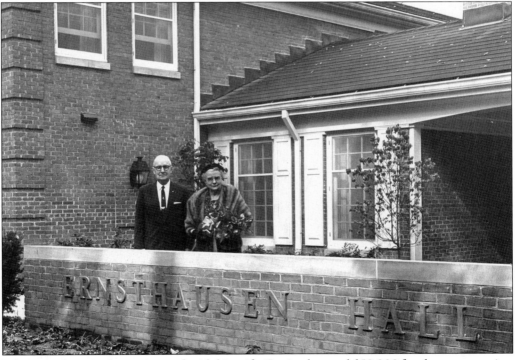

John Ernsthausen, here pictured with his wife, Doris, donated $50,000 for the construction of a new dormitory that was dedicated on October 19, 1961. Ernsthausen was a B-W trustee and counselor since 1946, a Berea Children's Home leader, and the owner of Norwalk Truck Lines. Doris was active in church and community. This building was the first Ohio college residence hall to make use of geothermal heating and air-conditioning when it was renovated in 2005.

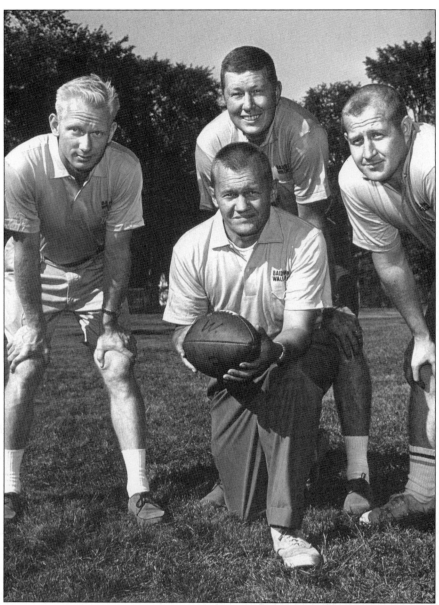

B-W football coaches Lee Tressel (front) and, from left to right, Dave Demmerle, Don Swegan, and Hugh Thompson are seen here in 1962. Football first began at the Berea colleges in 1893, but historical accounts contain conflicting information regarding the first game. One story claims that German Wallace College lost to Oberlin 84-0. Over the decades, B-W football has more than compensated for the early years, and the Yellow Jackets have boasted impressive successes, athletes, and coaches since. The influence of legends like the men seen here, and their successors, has endured to the present day. Alumnus and former placekicker Wade Massad graduated in 1989 and still recalls the profound impact of B-W's coaching staff. Citing men like Demmerle, he says, "As time goes on, you appreciate the character of the men, who were truly high quality educators." He notes that their coaching skills as well as their personal lives provided examples for student-athletes that were inspiring and long-lasting.

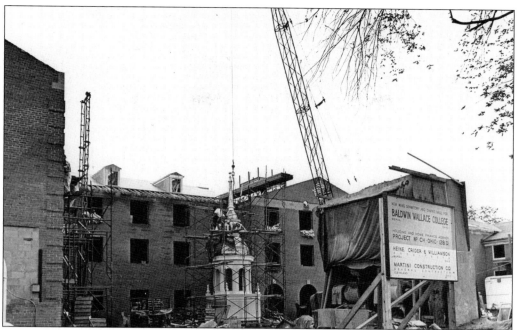

Heritage Hall was constructed in the early 1960s as a dormitory for fraternity men, replacing fraternity houses. Here the signature tower is being prepared for its ascent to its current place of prominence. Aside from the tower, Heritage is also known for a replica of the Liberty Bell outside the front entrance on Tressel Street. The piece was built specially for its B-W home using the original mold of the Liberty Bell in Independence Hall. The Heritage bell rang 13 times on July 4, 1965, in honor of the original colonies and 50 times in honor of the 50 states. Prof. Thomas Surrarer is seen ringing the bell below, years later. Today Heritage is the largest dormitory on campus and houses sororities, fraternities, and non-Greek students. It is also the home to residence life and the commuter lounge.

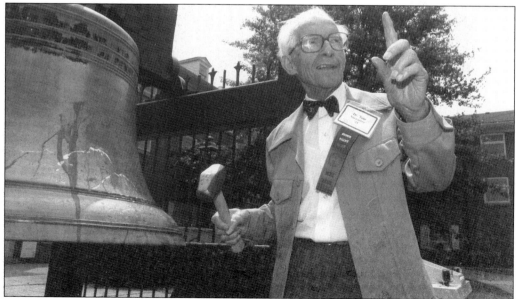

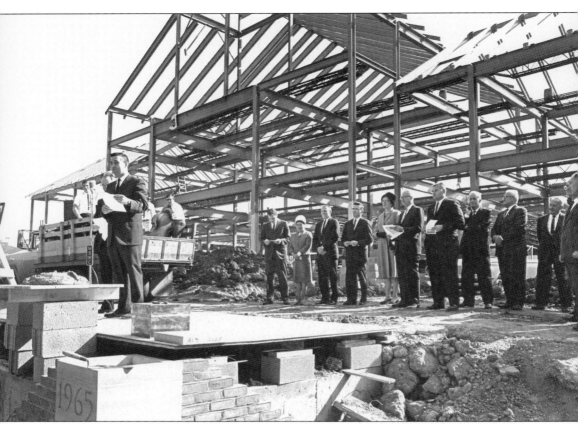

The Strosacker Hall–College Union is the modern center of campus life. It contains the Cyber Café, the bookstore (which was formerly housed in the basement of Marting Hall), offices, the Colony Room dining area, the service desk, and a main ballroom, which functions as a cafeteria by day and a social festivities arena at night. The College Union's cornerstone ceremony took place in 1965. Charles Strosacker came to Baldwin University in 1903 to study chemistry, but a professor suggested the Case Institute of Technology would better suit his goals. Strosacker followed his advice and launched a successful career. He became vice president of Dow Chemical in 1941 and was involved in developing the household product Cling Wrap. His gratefulness for the professor's advice inspired his generosity to B-W, and the College Union stands today as a result.

The completed Strosacker Hall–College Union (seen here during a homecoming celebration) is an impressive structure built in the Georgian Colonial style; its signature peak is fashioned after the House of Burgesses tower in Williamsburg, Virginia. The College Union was designed by Heine, Crider, and Williamson architects, a Berea-based firm that constructed a large number of buildings across campus. Cofounder Edward Crider attended B-W in the 1940s and completed his education at Ohio's Miami University. He worked for Mellenbrook, Foley and Scott, a firm involved in much construction across campus, before establishing Heine, Crider, and Williamson with friends. One of the firm's earliest jobs launched a career's worth of success. Crider recalls, "We started at B-W in 1958 with our first project, the renovation of Kulas . . . and that turned out so spectacularly that it gave us the opportunity to be the architects of B-W for the next 30 years. They dedicated the opening concert [in Kulas] to the architects. It was a real honor."

This photograph of students, taken at the 1964 freshmen orientation, shows the previously explained beanies still in existence. The tradition would last until the early 1970s.

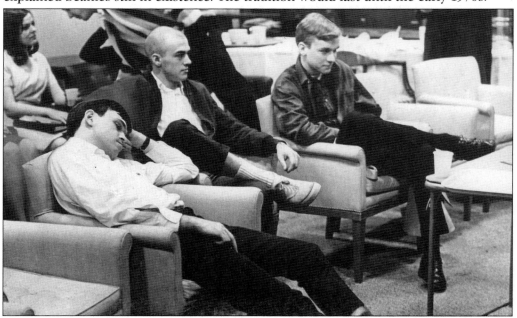

For David Pritchard, here caught dozing off, the cardinal rule "you snooze, you lose" did not apply. He was among a group of B-W students who took part in the 1966 College Talkathon, a 50-hour marathon of continuous discourse. Over 15 topics were discussed, including Vietnam and the draft. The event's success inspired a talkathon of 100 hours the following year, and the trend continued throughout the decade.

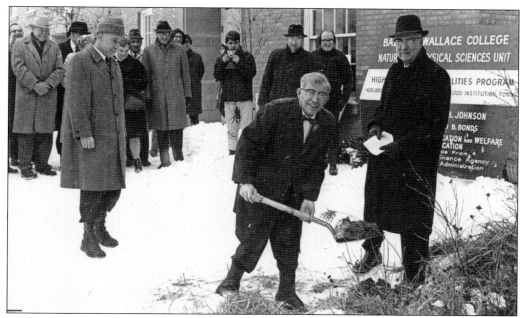

When physics professor Dave Proctor began his career at B-W, the life and earth sciences (LES) building, pictured below, did not exist. Proctor arrived on campus in May 1960 to find the physics laboratories in old Carnegie Hall "ankle deep in water." By the fall of 1966, however, the LES building was ready for use. The structure united the already existing Wilker Hall and McKelvey Auditorium and provided B-W with adequate classrooms, laboratories, and modern technology for science research. Its groundbreaking is seen above, with biology professor Thomas Surrarer holding the shovel beside A. B. Bonds. Surrarer served B-W for 45 years. During the 1960s, Proctor initiated a modernization of the physics course offerings, which were especially crucial amid the cold war. By 1970, courses were added for nonscience majors, including acoustics classes, which were soon required of all music students.

Robert Ebert began his career at B-W in 1967 and is still an economics professor today. He recalls teaching just two female business students during his first year. Now, he notes, it is not unusual for more than half of a business or economics class to be female.

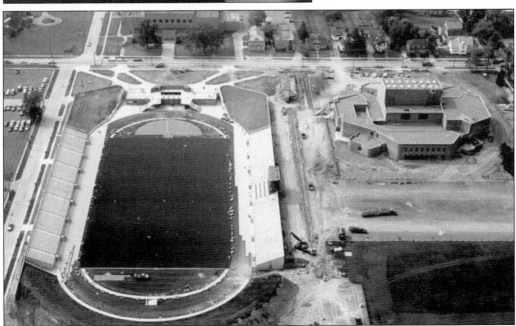

A bird's-eye view reveals the art and drama center under construction; it was completed in October 1972. The building was renamed the Kleist Center for Art and Drama in August 1994 in honor of Peter and Eleanor Kleist, who were longtime supporters of B-W. The building boasts a special roof, made of sheet lead and antimony alloy, which protects students and performers from the sound of jets flying overhead.

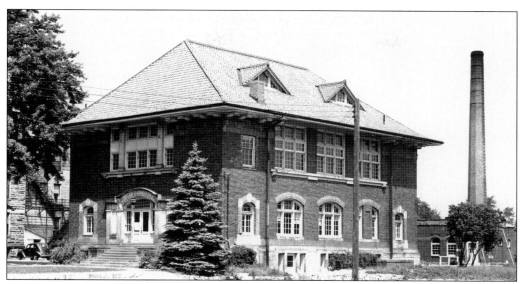

Ott Memorial Building housed the School of Commerce from 1946 until 1976, when Kamm Hall was built as the new home of business and economics classes. Professor emeritus Ron Ehresman (director of the business undergraduate division) worked in both buildings during his 36 years at B-W. He recalls colleague Robert Ebert's office in the basement of Ott, which flooded during times of excessive rainfall, as did a classroom in the basement. Furthermore, walking through the oft-flooded classroom was the only way to reach the bathrooms, so classes were frequently interrupted by people passing through. Such dilemmas were solved when friends, former students, and business colleagues of Jacob Kamm raised funds allowing for Kamm Hall (pictured below) to replace historic Ott.

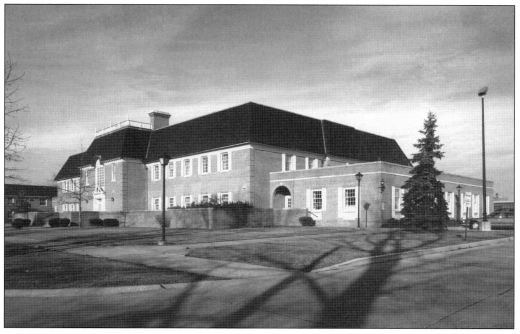

Jacob Kamm (1940), standing alongside A. B. Bonds (right), was an influential figure in the Cleveland financial community. He taught at B-W during the 1940s and into the 1950s and served as president of the Cleveland Quarries Company. Kamm touched countless lives with his dynamic teaching and investment wisdom.

Robert Drake, seen here working with a student, began teaching political science at B-W in 1964. He remembers when Neal Malicky arrived as academic dean in 1975, following a period of low morale on campus. Drake recalls of Malicky, "The first thing he did was come around to the offices of every faculty member. He just sat down and talked with us. This is why this guy was so good."

Cleveland native and American legend Bob Hope spoke at the 1977 commencement, entertaining the audience with his signature wit and also offering sincere words of wisdom. He told the graduates, "The world needs every one of you. It needs your ideas, your enthusiasm, and the benefits of your education." Hope was awarded an honorary doctor of humane letters from B-W.

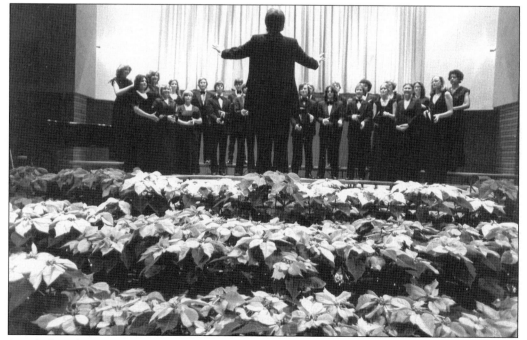

Amid abundant poinsettias, one can take a glimpse at the 1979 Christmas concert with Stuart Raleigh conducting. Raleigh is a critical component of the B-W conservatory in 2007, serving as professor of voice and conductor of the College Choir and Motet Choir.

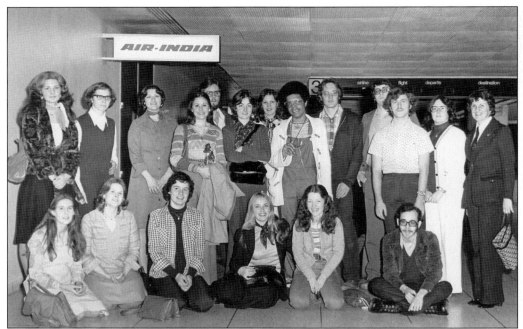

Students from the first Humanities Year trip are seen above. In 1975, Prof. Theodore Harakas and Prof. Andrew Talton initiated the program, which consisted of western civilization and language study on campus for two quarters, followed by a quarter in Europe. Students were afforded a unique, out-of-the-classroom experience for personal and academic growth. The program was supported by a grant from the National Endowment for the Humanities. After four years, the Humanities Year was altered and reintroduced as the Seminar in Europe, which continues to the present day. Pamela (Parobek) Eltrich (front row, far left) links the past to the present. Her nephew Bryan Parobek took part in the 2002 Seminar in Europe, and her son Adam Eltrich was a member of the same group in 2006. The image below shows the 1978–1979 Humanities Year group in Greece.

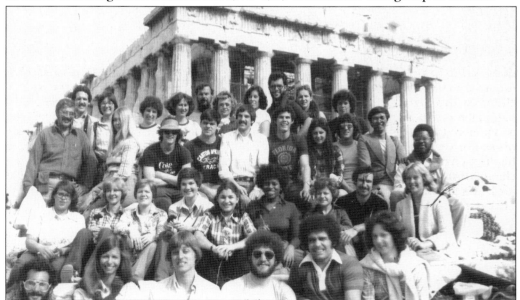

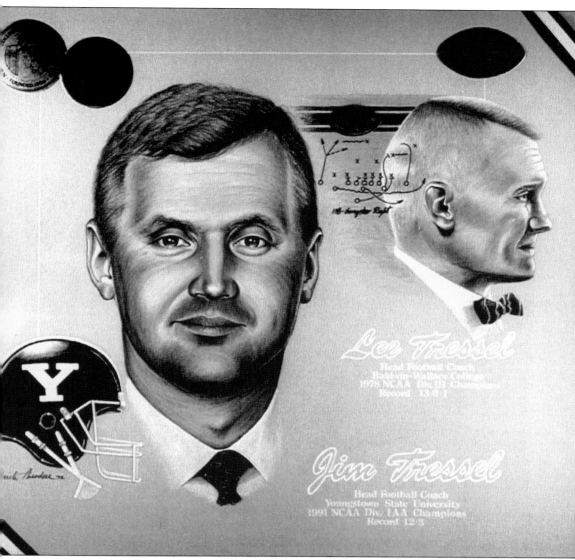

An artist's rendition of Jim Tressel (1975) and his father, Lee (1948), honors two B-W alumni with a high distinction. They are the only father and son to have each claimed a national football championship. Jim grew up in the atmosphere of football greatness; he was honored to play football for his father at B-W in the 1970s and was starting quarterback his senior year. Jim's career would later take him to Youngstown State University (and his first championship in 1991) and most recently the Ohio State University (and a championship in 2002). Lee Tressel clinched the Division III national championship title for B-W's football team in 1978. Lee and Eloise Tressel Street on B-W's campus honors Jim's parents and the legacy of one family's devotion and talent.

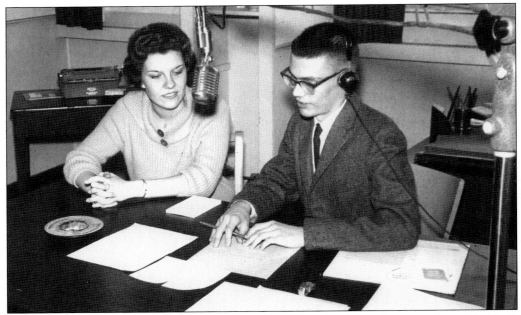

WBWC, "the Radio Voice of Baldwin-Wallace College," first signed on the air on March 2, 1958, as the first college radio station in northeast Ohio and the first completely student-funded, student-run radio station in the country. Students broadcasting in the early days are seen above. On January 19, 1970, a 105-hour radio marathon raised money for the Muscular Dystrophy Association and broke the collegiate record for longest continuous broadcast. On March 27, 1980, WBWC's first official marathon (one artist played for an entire broadcast day) took place; Elton John's music was played for 18 hours. In 1981, WBWC raised its power to 100 watts; seen below is chief engineer Dave Bobco celebrating with Neal Malicky (center) and A. B. Bonds (right). WBWC increased power to 4,000 watts in 2001.

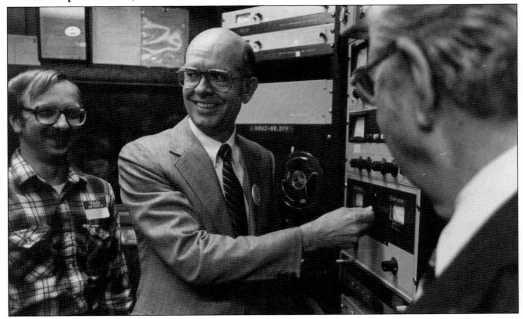

Four

THE MALICKY ERA

When we discriminate against another of God's children, our own humanity is lessened and our self-worth is lowered. We are damaged just as much as we damage others. Our need to eliminate prejudice from our lives is necessary for our survival as humans else we become what we hate.

—Pres. Neal Malicky

The presidency of Neal Malicky, from 1981 to 1999, was characterized by creative innovation in academics and student affairs, as B-W prepared for the dawning of a new century. "Quality education with a personal touch" became more than a slogan; it became the essence of the B-W experience.

This was an era of growth for B-W. Enrollment increased from approximately 1,800 to 3,100 full-time students, with an overall enrollment of 4,500. The endowment grew sevenfold, from $15 to over $114 million. Physical improvements were made, such as the development of the recreation center and major renovations of all the historic buildings. Off-campus and overseas programs were established, and the reputation of the school was enhanced, as illustrated by B-W's regular listing as one of the best colleges in the Midwest by *U.S. News and World Reports*.

Academic programs were developed to meet new and changing needs. These included criminal justice, sport/dance/arts management, music therapy, study abroad opportunities, and executive education in the business, corporate, and nonprofit communities. The international studies major was adopted as the first undergraduate major of its kind in Ohio. Increased support for faculty development promoted creative thinking and led to innovative student life programs such as SPROUT (Single Parents Reaching Out for Unassisted Tomorrows), providing the opportunity for single parents to obtain an education; the Freshman Experience, helping students to gain the best from their B-W years; programs in alcohol awareness and responsible sexual behavior; and efforts to enhance interracial and multicultural understanding.

In 1982, the Bach Festival ensemble received the high honor of displaying its talents at the John F. Kennedy Center for the Performing Arts in Washington, D.C. The college celebrated its sesquicentennial in 1995, marking "150 years of leadership in learning" while preparing for the challenges a new century would surely bring.

Neal Malicky, pictured with his wife, Margi, graduated from Baker University in Baldwin, Kansas, a town named for John Baldwin. Malicky served as president from 1981 to 1999. For almost 20 years, his license plate read "BW-2001," reflecting B-W's purpose of providing an education to prepare students for leadership in the 21st century. Malicky also coined B-W's motto, "Quality education with a personal touch." Around 1982, he incorporated the phrase into a speech, emphasizing the importance of high-quality standards and individualizing B-W's education to take each student's needs seriously. Malicky explains, "With about 120 or so people in the room, in the midst of the speech, a member of the faculty responded audibly when he heard the phrase, 'That's it! That's what we do!'" From there, the slogan was used in B-W literature and became official. Ten years later, B-W hired an advertising firm to recommend a new look for the college literature. The firm initially said the slogan was outdated and had to go. However, after a four-month intensive study of the campus, the firm was surprised by how many faculty and students defined the college with that phrase. The firm changed its recommendation, and the slogan stayed. As first lady of B-W, Margi hosted more than 2,000 people a year in the president's house for dinner, receptions, and other B-W events.

The president's house, seen here in 1982 following renovations, was built in 1935 and was first occupied by Louis Wright. The Georgian Colonial mansion served as both a place of residence for presidential families and center of entertainment for college receptions. In 1992, the Malickys built a private home, and the majestic building was then used as the alumni house. In 2006, the house again switched functions and is currently occupied by college president Richard Durst and his wife, Karen.

Humanitarian Albert Gray was an economics professor at B-W from 1967 to 2005. He is seen here (center) with his wife, Louise, and a friend at a 1982 New York City peace march. Countless B-W personnel cite his acquaintance as one of the most special of their careers. The Grays traveled extensively promoting human rights and peace. "There are all kinds of wonderful people that came across our path," Louise recalls.

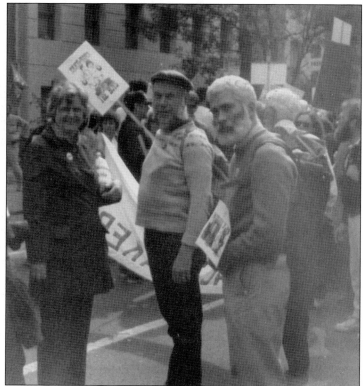

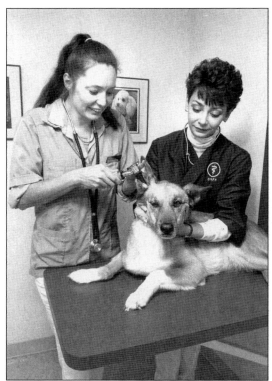

Field experience opportunities put students in the work world, helping them to gain credentials, make contacts, and navigate possible career paths. B-W was a leader in this growing movement, and student Michelle DeWerth is seen here working with Dr. Linda Wiley at the Metro Pet Hospital. DeWerth is examining Gretta as part of her internship.

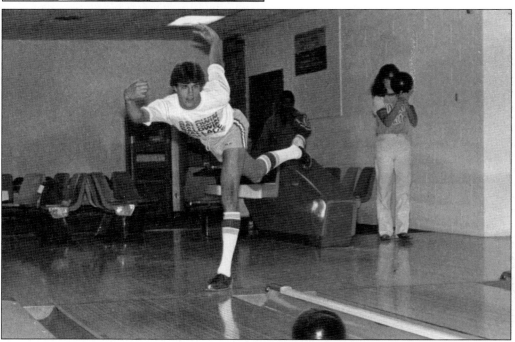

If students wanted to show off their bowling skills to some friends, they could just go to the College Union basement and have some fun in the game room. This picture, taken in 1982, shows the bowling lanes that used to exist where the sandstone conference rooms are today.

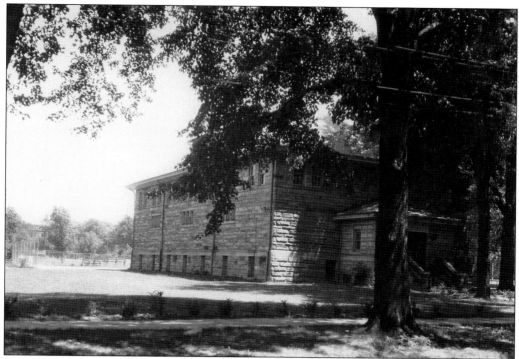

Many creative programs characterized the Malicky era, including new approaches to healthy lifestyles for students. The former women's gymnasium (above) was converted to a nonalcoholic party center to provide students with an attractive, nearby entertainment location. The *New York Times* featured the center as a creative concept in the effort to reduce drinking on campus. Also, the former Cleveland Browns training center (below), which at the time of its construction was one of the best in the National Football League, was transformed into a student residence hall in which alcohol and tobacco were forbidden.

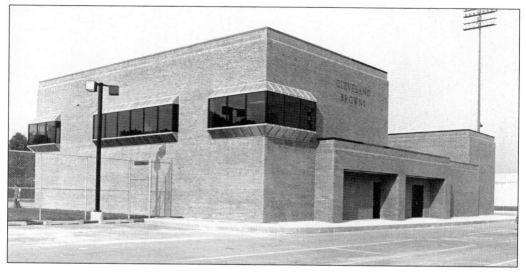

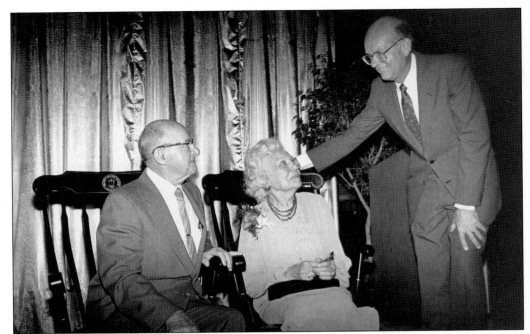

Neal Malicky congratulates Theo and Belle Moll upon announcement of the Chair in Faith and Life named in the couple's honor. Theo was first elected to the B-W Board of Trustees in 1965 and served as founder and director of MTD Products, Inc. His family, friends, and business associates established the Chair, which would promote religious studies and create a lecture series, to recognize the Molls' dedication to B-W.

Professor of history Louis Barone is seen here in 1988. Today he jokingly recalls the early days following his arrival on campus in 1966. "I was the baby of the department, and [a colleague] said, 'Lou, you'll always be the baby of the department.'" Known for his quick wit in and out of the classroom, Barone has also devoted decades to the development of Yellow Jacket athletics.

William Hebert was one of the most influential and talented conservatory instructors in recent years. He is seen here in the 1980s giving a flute lesson to Amy Gibbons. Sean Gabriel, a former student of Hebert's who now teaches at B-W, recalls, "He was a wonderful, insightful teacher who brought his many years of performing with the Cleveland Orchestra to his studio expertise."

Members of the Newman Student Organization chat with incoming freshmen at the 1992 orientation. Through service, faith, sharing, education, worship, personal relationships, and celebration, the organization works to foster the spiritual growth of B-W students and the community. Weekly Catholic masses are held, with dinner served afterward. The group also takes part in retreats and other faith-based activities.

John Golubic, class of 1988, dresses as a Yellow Jacket in a show of school spirit. Athletes were first called Yellow Jackets in a 1927 newspaper account because of B-W's brown and gold uniforms. The term was documented in the 1930 yearbook and thereafter accepted as the official school mascot. Philura Gould Baldwin, class of 1886, had suggested brown and gold as the college colors.

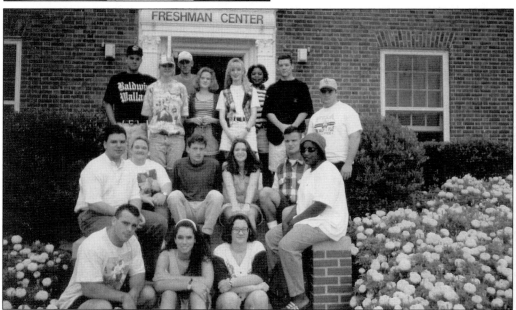

Here pictured are students from the Freshman Experience program, commonly known today as College 101. Neal Malicky explains, "It began with seven sections, of approximately 15 students each, and quickly grew to serve over half of the entering first year students." National expert on the topic John N. Gardner made many visits to B-W and helped train faculty in implementing the innovative program.

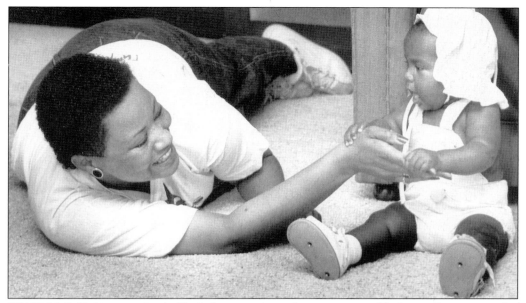

SPROUT Hall director Rochelle Roberts enjoys the company of baby Andrianna in the early 1990s. Andrianna's mother, Tara Stephens, was among the first participants in the SPROUT program, created at B-W to help single parents gain an education and become financially self-sufficient. Andrianna returned to B-W in 2006 as a high school student to take postsecondary classes in psychology.

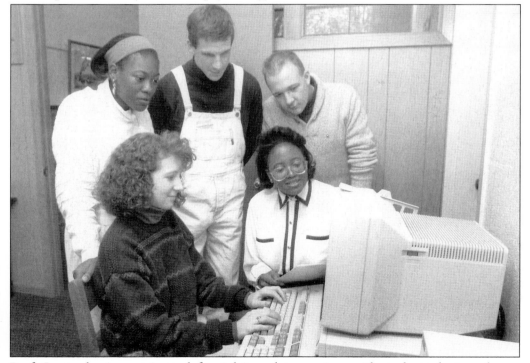

Prof. Cassandra August (seated, far right) analyzes recipes with students during a home economics class in 1991. The group is working in Ward Hall, which was built in the early 1950s and named in honor of Rev. Jacob Ward (1789–1869), a local Methodist pioneer.

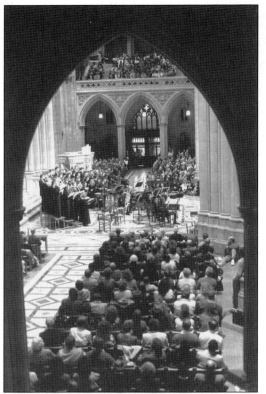

In 2000, the B-W choir performed under the direction of Stuart Raleigh at the National Cathedral in Washington, D.C. An audience of over 2,000 enjoyed the show, which was the opening concert of the Music Educators National Conference annual meeting. The choir was invited to perform as part of a yearlong series of concerts celebrating the cathedral's dedication.

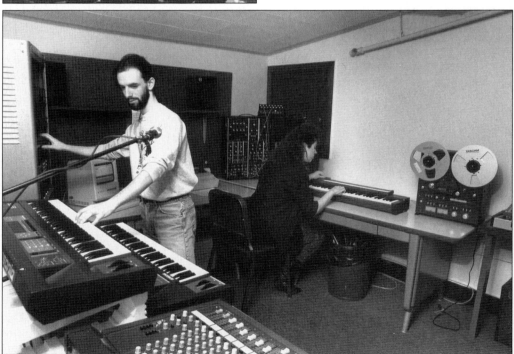

This electronic piano room, created by Lawrence Hartzell, is the innovative 1980s counterpart of the keyboard room developed by Carlton Bullis in the 1940s.

In 1959, the first Dance Concert was held at B-W. A few years later, the dance program was formed to give students a creative option for an academic minor. Dancing and choreographing skills are showcased yearly in Dance Concert, seen here in the 1990s, which continues to be a lively and anticipated campus event.

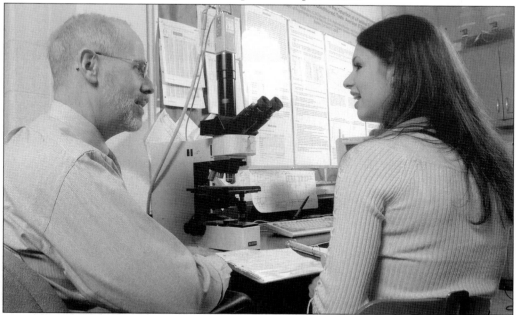

Dr. G. Andrew Mickley and student Amy Jo Marcano-Reik discuss her neuroscience senior thesis at the microscope. Under the auspices of the biology, chemistry, and psychology departments, Mickley developed the interdisciplinary neuroscience program; a minor was approved in 1996, and a major followed in 2000. Participants have since become prominent scientists, physicians, and other clinical practitioners. Nu Rho Psi, the national honor society in neuroscience, was founded at B-W in 2006.

Alumni pride has run deep since the days of John Baldwin, and countless former students proudly define themselves as members of the B-W family. The alumni association organizes special events on campus and within the community, and it also supports the formation of alumni chapters across the country. In the photograph below, the phrase *B-W family* gains a literal meaning. Cathy Waters, class of 1991, is seen with a group of her family, each of whom graduated from B-W. Their class years date back to 1957.

Dorothy McKelvey served as the college historian from 1960 to 1993. Associate director of college relations and former B-W student Helen Rathburn remembers, "Dorothy was devoted to Baldwin-Wallace and its traditions. Those of us who worked with her knew that whenever we stopped by her office, no matter the reason, we would leave with a new tidbit of historical information about B-W."

Louise Kiefer, current historian, was McKelvey's successor, although her career with the college began much earlier. Kiefer graduated from B-W in 1942 and began teaching German soon after. She became a full-time professor in 1958 and served as department chair from 1974 to 1990. The Ohio Foreign Language Association named Kiefer recipient of the Excellence in Teaching Award in 1990. She also received an Alumni Merit Award in 1997.

Leadership of the college is provided by many people in many different responsibilities. Pictured above are members of the president's council in the 1990s. From left to right are Dr. Mark Collier, VPAA, who provided leadership for the educational program, including the faculty, curriculum, and related matters; Keith Matthews, vice president for finance, who was in charge of financial issues, including buildings and grounds, food service, and related concerns; Pres. Neal Malicky, who kept B-W looking ahead to the 21st century and supported the development of innovative programs in academics and student life; Dr. Obie Bender, longtime executive assistant to the president, who was in charge of varsity athletics, the recreation center, and information technology; Dr. Denise Reading, vice president for student affairs, who led dynamic programs in student development, including residence life, the health center, and counseling; and Richard Fletcher, vice president for advancement, who headed fund-raising, alumni affairs, and external relations.

B-W baseball began in 1894 when teams were formed at Baldwin University and German Wallace College. Today the team is a member of the Ohio Athletic Conference and promotes the development of student-athletes who excel on the field and in the classroom. Baseball head coach Robert Fisher graduated from B-W in 1963 and returned five years later to lead the team, where he has remained ever since. Fisher, who also serves as a classroom professor, has built the baseball team into one of the best in the NCAA Division III. Pictured below is Heritage Field, thus named due to its location behind the college's largest dormitory. The first athletic field on campus was built in 1910, located where the College Union is today. It was accompanied by the addition of a new gymnasium (currently the student activities center).

The Institute for Learning in Retirement (ILR) was founded at B-W in 1992. It would grow through the years, later celebrating its 15th anniversary with over 940 members and offering 52 courses. The program's volunteer nature makes it very unique; retired teachers and professors donate their time to fostering intellectual pursuits among their fellow retirees. Classes are held on a noncompetitive and noncredit basis. The 1995 steering committee is pictured here.

Martin Luther King Jr. called James Lawson the "leading nonviolence theorist in the world." Lawson, B-W class of 1951, is seen here speaking at the 1994 commencement. He was involved in nearly every major civil rights event of the 1960s but preferred a behind-the-scenes role. He opposed segregation and the draft; his nonviolence training workshops produced some of the most influential civil rights activists of the ensuing decades.

World-famous figure skater Tonia Kwiatkowski graduated from B-W in 1994. She reminisced, "B-W was wonderful not only for the education I received but for their support with my skating career. Because of the support I received, I was able to compete nationally and internationally with some of the best skaters in the world." Kwiatkowski received dual degrees in communications and psychology at a time when few nationally ranked skaters reached college.

After extensive renovation, Wheeler Hall was rededicated in September 1995. The new Amelia and Clara Harding Center for Teacher Education was also dedicated. Amelia graduated from B-W in 1936, and her sister Clara is an honorary alumna from the class of 1993. The Hardings hope that the center will prepare students to think clearly, develop sound judgment, and come to understand the people around them.

During the autumn months of 1996, the Philura Gould Baldwin Memorial Library received the spa treatment after a century of wear and tear. Carnegie Hall was also cleaned, helping to restore the luster to some of B-W's most historic buildings.

Adrian Ross, 1994 alumna and daughter of economics professor Thomas Ross (1967), was the White Rose Ceremony orator for her graduating class. Here she is shown replacing the previous year's withered white rose with a fresh one, continuing the tradition set forth by John Baldwin Jr. and his family in honor of Philura Gould Baldwin. The single white rose symbolizes youth and purity.

Campus-wide celebrations took place during the 1995–1996 school year to honor the 150th anniversary of the founding of Baldwin Institute. The motto for the sesquicentennial was "150 Years of Leadership in Learning." A kickoff celebration featured over 60 members of the B-W community dressed in period costume, including, from left to right, college president Neal Malicky (portraying John Baldwin), dean of student affairs Denise Reading, and academic dean Mark Collier.

A 1987 Berea Summer Theater (BST) performance of *Quilters* is seen here, featuring (from left to right) Debbie Richards, Mary Eileen Fogarty, Barbara Winbigler, Barbara Daugstrup, and Cindy DeFlorientis. Early BST shows were staged in the recreation hall, a V-12 building that formerly existed on the current-day College Union lawn. In 1972, BST took up residence in the new art and drama center.

William Kelso, class of 1963, is among the top archaeologists of early American history in the nation. His conviction that the James Fort was not washed away, as common belief held, led to the breakthrough rediscovery of Jamestown in 1996. Ongoing excavations have unearthed over one million objects that shed light on the Colonial town. Kelso credits "a sound training in liberal arts and history at Baldwin-Wallace" with helping to propel his career.

B-W first offered business classes on Cleveland's east side at the Ramada Inn. By 1994, the college moved its east side presence to the current location in Beachwood, on Science Park Drive. Business classes are offered through a flexible schedule to allow students to maintain jobs while earning their degree.

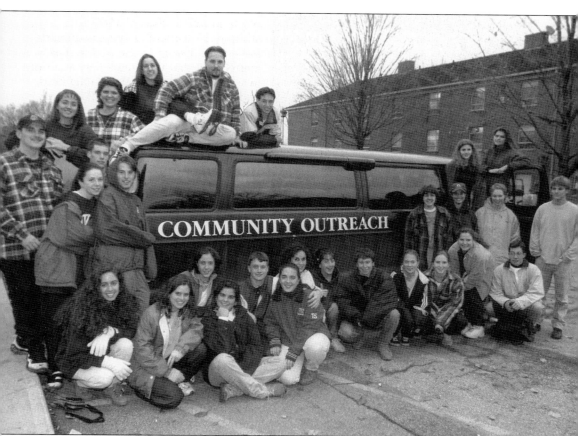

B-W students gather in groups for more than mere socialization; they come together to serve, in the community and around the country. This particular group went to North Carolina in November 1996 to help clean up after Hurricane Fran. The Office of Community Outreach (OCO) helps coordinate these service projects. Former OCO director Gretchen Carlson (1996) is part of the team (top left, in plaid). Alternative Break trips give students an opportunity to travel while exploring social justice issues, through such tasks as building homes and offering disaster relief. The foundation of the OCO was established in 1985 with the formation of the B-W Construction Company, which offered open forums every two weeks to raise awareness of fragmentation and prejudice in the community. By 1987, nearly 20 service programs were created, including Big Buddy/Little Buddy tutoring. The early 1990s saw the formation of the OCO, marking an ideological and financial commitment to the community. Since then, outreach at both the community and international levels has multiplied, and the OCO serves as an integral espouser of John Baldwin's ideals.

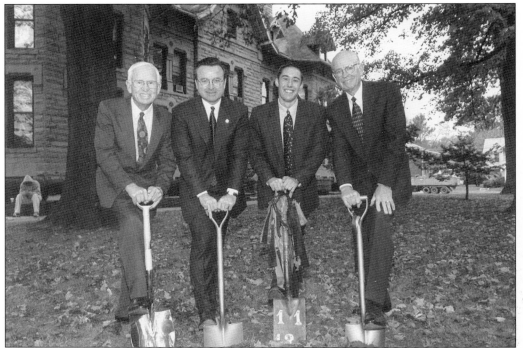

The groundbreaking for the Malicky Center for the Social Sciences took place homecoming weekend in 1998. Pictured above are (from left to right) trustees Glenn W. Snow and William B. Summers (1972), student body president Erik Gottfried (1999), and college president Neal Malicky. The new building contained 1,700 square feet of classroom space and united Carnegie Hall with the Philura Gould Baldwin Memorial Library. Renovations also took place to restore the two historical buildings in preparation for a new century of learning. The impressive finished product is pictured below.

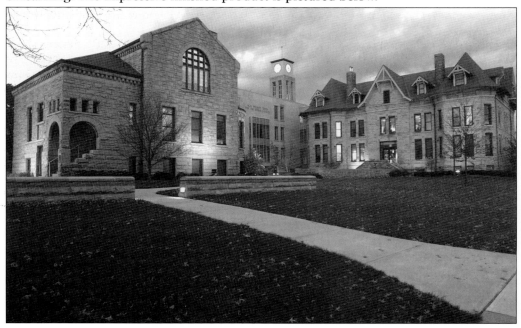

Five

EDUCATION FOR THE 21ST CENTURY

The focus of my vision for this College is a community of faculty and staff who clearly and unapologetically understand they exist as a community for the purpose of changing, of transforming the lives of students.

—Pres. Mark Collier

When Mark Collier was inaugurated president in October 1999, he recognized the challenges B-W would face in the new century, including globalization, rapid changes in higher education, and rising competition among schools. Collier expressed, "I felt we had to find a way to successfully meet those challenges while still remaining faithful to our traditions as a first-rate, church-related, liberal arts institution."

During Collier's presidency, the college gained a new mission statement and strategic plan. A campus master plan was developed, which included the renovation of the recreation center and Ernsthausen dormitory and a fund campaign to implement those goals. A statement on B-W's relationship with the United Methodist Church was also established.

The core curriculum was updated and now includes a liberal arts and sciences (LAS) course, LAS 150 (Enduring Questions for an Intercultural World). This course is taken by every B-W student and familiarizes them with foundational thinkers in the humanities, social sciences, and natural sciences. Students apply readings from these thinkers to current events and examine the ways culture shapes alternative perspectives on humans' relations with one another and the natural world.

Collier's administration also fostered links between vibrant campus life and social outreach. Dance Marathon, a service event utilizing student-organized fund-raising, was established, and outreach projects took students to the streets of Berea and across the country. Mid-Night Madness was founded in 2000 as a nonalcoholic, weekly night out for students. A familiar face at college events, the president never missed a chance to chat with students about their B-W experience.

Richard Durst was inaugurated as B-W's eighth president in October 2006. He said in a 2007 interview with the author, "Every private school says they're about relationship building, but we're a school that puts that into action."

Mark Collier, seen here greeting graduates, served as president from 1999 to 2006. His career at the college, however, spanned 32 years, beginning in 1974 when he became chaplain. He later became associate academic dean and VPAA before taking the presidency. Professor of history Indira Gesink notes that Collier's powerful and motivating speeches have had the power to deeply inspire their listeners. One of Collier's truest distinctions is his genuine concern for the success of others. Consistently his top priority was getting to know the students and being available whenever someone needed help. Shawn Gaines, a 2006 graduate, recalls, "Whenever I talked to President Collier, or heard somebody talk about him, it was never all the relationships he formed or the feats he performed or the lives he aided that struck me. It was the fact that, when we looked to our leader, we saw someone caring, altruistic, and genuine, and we knew those traits could make a person successful."

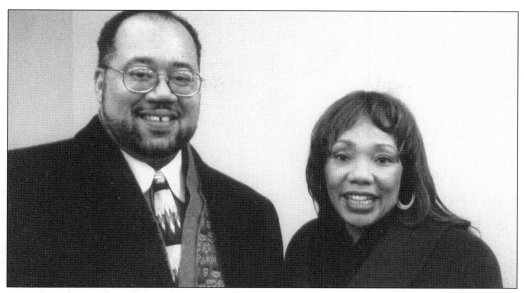

Assistant dean of students Jay T. Hairston is pictured above with Yolanda King, eldest daughter of Martin Luther King Jr. In 1999, Yolanda visited B-W as part of the Academic and Cultural Events Series (ACES), a program that sponsors campus events of intellectual and cultural interest. ACES partners with academic departments and student organizations to provide guest speakers, musical artists, workshops, and field trips to the campus community. ACES also coordinates Martin Luther King Jr. week at B-W. This celebration includes a candlelight walk across campus (seen below) in remembrance of those who marched for the civil rights movement and also in honor of all human rights. After the walk, participants discuss what they can do to make the world a better place. As Hairston notes, "One little flame of light can dispel racism and injustice."

Past meets present in this image of the Malicky Center's room 200, holding one of its first classes after the new building's construction. This classroom was formerly part of the Philura Gould Baldwin Memorial Library, and the beautiful stained-glass windows honor the Baldwin family. Standing in the room, one feels the transcending, majestic beauty of its history, for the space is a timeless tribute to John Baldwin's granddaughter.

This gate, located by the Malicky Center, was a gift from trustee Walter Mueller (class of 1950) and his wife, Elaine. Walter helped B-W jump-start its campus master plan, which included creating an entrance to the campus and turning Bagley Road into a more scenic boulevard.

The Voices of Praise Gospel Choir (VOP) was formed at B-W in 1975 through the initiative of five African American female students who loved singing. The choir's humble beginnings soon led to student senate recognition in 1977 and independent group status. Sharon Wilson Colden, who was among the initial founders, served as director until 1995, when gospel recording artist Jay T. Hairston took up the post. Increasingly, VOP became recognized on campus and in the community, performing at numerous functions, including Mark Collier's inauguration. Continued success has led to VOP performances across the country and internationally. The choir performed at the Krefeld Music Festival in October 2006 as a special guest for the 10th anniversary celebration; it was VOP's second time attending the festival. Pictured here are photographs from VOP's trip to Disney World in March 2000, featuring an exciting and well-received performance on the Tomorrowland stage.

September 11, 2001, hit close to home at B-W, where alumni were among the thousands missing, and the community shared the disbelief and pain that swept the nation. "How the campus responded to September 11th I will always, always remember," Mark Collier recalls with emotion. Gatherings were held throughout the week to pray for everyone involved in the tragedy, and hundreds took part in the candlelight vigil before Kulas Hall, seen here.

Student Stephanie Hume displays a shirt created by International Student Services (ISS). As director Rong Song explains, the goal of ISS is to help international students enjoy B-W as a "home away from home." ISS also provides programs across campus to promote cultural awareness and diversity; some of these events include Culture Night, an evening of entertainment and food; the Chinese New Year celebration; and weekly coffee hours.

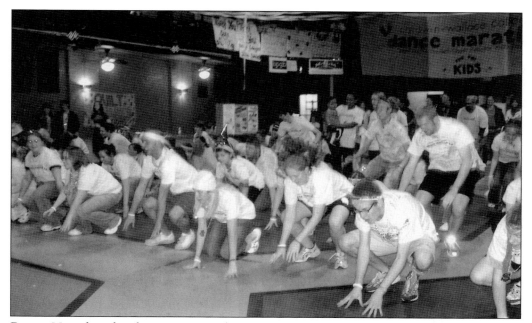

Dance Marathon has been an annual event at B-W since 2002. For a designated period of time (either 12 or 24 hours), the students involved must stay on their feet and dance. They gather monetary donations in support of their participation, to benefit the Elizabeth Glaser Pediatric AIDS Foundation. The 2007 marathon earned over $20,000. Students learn fun new dances and are encouraged by "moralers." Various campus entertainment groups make appearances to keep everyone energized. Also, for weeks preceding the event, large posters are decorated and personalized cards are made to transform the student activities center into a place of inspiration.

Technology cannot replace treasured artifacts, as seen by modern students' use of the Riemenschneider Bach Institute Library. Albert Riemenschneider founded the Bach Festival in 1933. He also collected priceless artifacts, such as first-edition scores, manuscripts, books, and other memorabilia, which formed the basis for the Riemenschneider Bach Institute over a number of years. The institute was established in 1969 with the library at its core, attracting scholars from across the globe.

B-W's new marching band made its debut during the fall of 2007, under the leadership of Ken Mehalko (1961). Such a band had formerly existed at B-W, and its return to campus was a highly anticipated and exciting event for the campus. A generous donation from Del Spitzer, a 1951 B-W graduate and trustee, and his wife, Anne Benedict Spitzer (1954), helped support the band's formation.

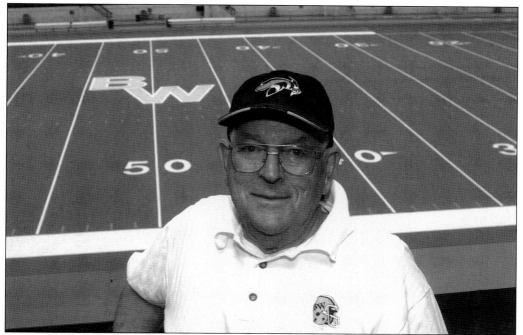

Roy Seitz, who graduated from B-W in 1943, has been a devoted volunteer in the athletics department for over 50 years. He was inducted into the athletic hall of fame in 2006. Seitz, a loyal Yellow Jacket, is also known for the friendliness he exudes wherever he goes. With a smile, he says everyone calls him "Uncle Roy."

The Lou Higgins Center is the crown jewel of the B-W athletics facilities. Originally constructed in 1986 to improve upon the Ursprung Gym, the center was renovated again in 2004. The result was a state-of-the-art facility containing the amenities of a country club plus classrooms and offices, making academic learning and athletic pursuits comfortable, convenient, and top-notch.

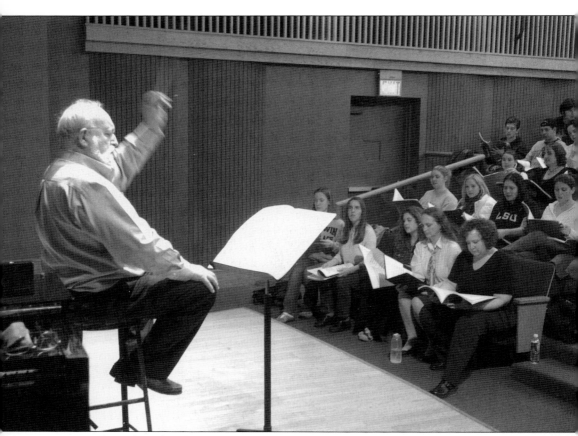

Krzysztof Penderecki, the internationally renowned Polish composer, took part in B-W's FOCUS Festival of Contemporary Music in 2005. The festival brings a guest composer to campus for a week of student interaction and discussion. At the conclusion of the week, two concerts of the composer's music are held. Courtney Becker, a music therapy major who graduated in 2006, recalls her FOCUS Festival experience. "Working with an innovative, successful composer is one of the most invaluable real-life experiences that any music student can hope to have. When Krzysztof Penderecki spent time with students and faculty, it provided an opportunity not only to study and perform challenging and current music, but also to work with an internationally known and respected expert in our chosen field. After taking part in a successful performance under the baton of Penderecki, I personally felt very confident that the musical education I was receiving from the Conservatory would serve me well in any musical endeavors I chose to pursue."

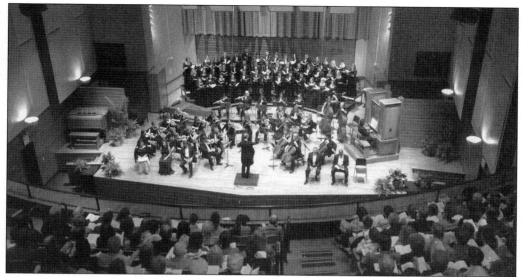

B-W's Bach Festival, seen here in 2006 with Dwight Oltman as conductor, is the oldest collegiate Bach celebration in the nation. Every spring, a weekend is devoted to the moving music of Johann Sebastian Bach, and conservatory students perform alongside internationally renowned guest musicians. Oltman (pictured below) has been at B-W since 1970. He remembers starting the jazz band during his early days at B-W. "Some people were very upset, saying we shouldn't be playing that kind of music in Fanny Nast Gamble Auditorium!" Discussing the conservatory as a whole, Oltman said, "I think faculty members tend to come here and stay for most of their careers because it's an environment where we enjoy working, we enjoy the students, we enjoy each other, so we tend to have longevity. We're not always looking for greener pastures because we think it's pretty green where we're at."

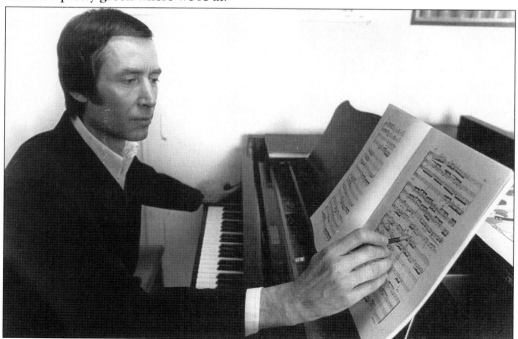

Ask a B-W student who has studied abroad to talk about their experience, and chances are one will hear something similar to the words of Kevin Risner or Kathryn Redfern, class of 2006. Risner, seen above on Arthur's Seat with Edinburgh as a backdrop, recalls this moment as transcending: "A sense of accomplishment and contentment enveloped me. I couldn't think about anything else, but the sky, being there, and feeling like this was everything I was missing. I felt fresh and real and glad to be me right then. It almost felt like an eternity." Redfern, pictured in Venice overlooking the Grand Canal, remembers seeing the Basilica of St. Mary of Health/Salvation (in the background) and being struck by its beauty. As an aspiring teacher, Redfern's ventures were priceless, and she now applies her international experiences in the classroom.

Adventure, learning, and one-of-a-kind moments are seen here during the 2004 Ecuador trip, a B-W study abroad opportunity. Above, a group of students explores the Galapagos Islands. Below, Evan Kardon is seated next to a Galapagos tortoise in the Charles Darwin Research Station on the island of Santa Cruz. Biology professor Michael Melampy started the Ecuador program in 1989. A two-week trip over Christmas break has evolved into a semester-long program, including six weeks of study at B-W followed by nine weeks in Ecuador. Students earn credit in tropical ecology, Latin American literature, and Spanish. Melampy explains, "A central goal of the program is to build understanding of Ecuador's incredible natural diversity and the threats that exist to the sustainable management of this diversity." English professor Terry Martin joined the program in 1997, teaching the literature portion.

Biology professor Jacqueline Morris earned a grant from the National Multiple Sclerosis Society, which is allowing students to study nerve functions in zebra fish and make connections to the human nervous system. Student Don Brown is seen above working with the fish in the LES building laboratory. Morris explains that addressing real-world topics in a liberal arts college is critical for both the school and its students.

Students rake leaves alongside college president Richard Durst during the fall 2006 Saturday of Service. This event was organized as part of Durst's inaugural weekend. The OCO works with dozens of organizations to coordinate days of service for B-W students, faculty, and staff. The OCO's assistant director Julie Bishop explains that oftentimes these projects are held in conjunction with the city of Berea, such as the restoration of historical Coe Lake.

This smiling group of Phi Mu sisters is prepared for both April rain and April Reign. The latter is a yearly tradition that began in 1999. It replaced May Day celebrations when B-W changed its calendar to one based on semesters instead of quarters. The festivities include two days of picnics, sports competitions, and a concert featuring a popular band or solo artist. The first April Reign brought Toby Keith to campus, and recent years have included performances by Maroon 5 and Josh Gracin. Pictured below are the chariot races, with the men of Phi Kappa Tau surging past cheering crowds.

Matthew Florjancic, a broadcasting/mass communication major, gained invaluable experience through an internship with WEWS TV in Cleveland. One of the most exciting aspects of his job was interviewing members of the Cleveland Indians.

The class of 1955 celebrated its 50-year reunion on the back lawn of the alumni house, with friendly yellow jackets hovering near. These former students graduated during the same year that A. B. Bonds began his presidency and subsequent B-W legacy.

The Adams Street Cemetery Project began in May 2006 as a service project conducted by B-W history students for the community. Pictured above is history department chair Indira Gesink (far left) with her group of student interns (from left to right, Megan West, Jeremy Feador, Allen Stewart, Ashley McMillin, Dan Maxymiv, and Monica Scullen). The cemetery is the oldest burial ground in Berea, but over the years, it has fallen into major disrepair. Project participants faced the challenge of identifying unmarked graves and piecing together the stories of forgotten citizens, including Civil War veterans. Gesink explains that such projects afford students the chance to apply their history education toward civic-minded career opportunities. Feador and Maxymiv are seen below with Terence Hamill, of GeoSearches, Inc. Hamill is using a ground-penetrating radar scan, which detects unmarked graves and produces an image of what lies below.

Suzanne Strew carries the ceremonial mace, an honor bestowed upon the senior faculty member each commencement. A. B. Bonds designed the mace, which art professor David Williamson created, and gave it as a gift to B-W when he retired. Strew came to B-W in 1957 to teach in the women's health and physical education program; she started the dance program and became an active proponent of the arts on campus. She received the first annual Carl S. Bechberger Award for Student Development at B-W as well as the Distinguished Faculty Leadership Award. Strew choreographed numerous musicals and operas, and she directs the Dance Concert program each spring.

B-W's musical theater program, established in the 1980s, is today among the best in the United States. Conservatory faculty member Victoria Bussert has played a large role in developing that success over the past decade. Graduates of B-W's musical theater program perform across the country and internationally. The 2006 *Sideshow* performance is seen here, with student Andrew Schmidt standing before the cast.

The David Brain Leadership Program offers an interdisciplinary minor in leadership, which promotes the idea that through service and ethical action, all can be leaders. The program also brings effectual guest speakers to campus, including Sr. Helen Prejean, pictured greeting students and faculty for autographs and discussion. Prejean is the best-selling author of *Dead Man Walking*, and in her B-W lecture, she shared her experiences working with criminals on death row.

John Baldwin's vision was not limited to the United States alone. His donation of $3,000 in 1881 to begin two schools in India was an early investment in global education and showed his understanding of the need to build bridges between societies through education. Today the Baldwin Institutions (which include the Baldwin Boys' High School, the Baldwin Girls' High School, and six others) are thriving, and B-W continues to strengthen its ties to Baldwin's namesakes while expanding its links to other Indian institutions of higher education. Here pictured by the Taj Mahal are, from left to right, Tina Cochran, Dr. Judy Krutky, and Christie King-Shrefler, from the offices of admissions, the academic dean, and explorations, respectively. They traveled to India during the summer of 2006 to explore educational exchanges and study abroad opportunities for B-W students. This has opened the door for B-W students to study at India's Christ College and for Indian students to study at B-W. In December 2007, a group of students and faculty leaders traveled to India and took part in lectures and workshops at Christ College. Richard and Karen Durst, as well as Aaron Baldwin (a descendant of John Baldwin), joined the group in a true display of historical continuity.

Richard Durst was inaugurated as B-W's eighth president on October 27, 2006. While many people look to him for a vision of B-W's future, Durst strongly believes that people across campus must take part in the visioning process. He maintains that B-W's foundation will always be a liberal arts education; students with a broad-based education can talk about a variety of topics coherently, and they are better citizens of the world. The liberal arts tradition can be further solidified, however, by focusing on B-W's existing strengths and realms of national prominence and making them even stronger. Durst believes that identifying areas of comparative advantage will build upon B-W's past successes while establishing further improvements. "Richard Durst is an international authority in theatre set design and the role of theatre in colleges," said John Kropf, chair of the B-W Board of Trustees. "He has a warmth, presence, and academic stature that connected with all of the portions of our college community."

These three professors, who retired in 2006, represent 113 years of combined service to B-W. Edgar Moore (left) came to B-W in 1962 as chaplain and joined the history department the following year, where he stayed until retirement. Lawrence Hartzell (center) graduated from B-W in 1964 and returned within a decade to teach music theory. Ronald Ehresman (right) arrived in 1970 with a "one-year, non-renewable contract" to teach business.

Azar Nafisi, best-selling author of *Reading Lolita in Tehran*, spoke at B-W in September 2006. Nafisi, a champion of universal rights that transcend cultural boundaries, was an ideal guest to inaugurate Enduring Questions: the Mark Collier Lecture Series. The series, established in honor of former president Collier, invites speakers from a diverse range of academic disciplines to discuss timeless issues of humanity and society, questions that have existed since the earliest civilizations.

The Barbara Byrd Bennett Scholars Program began with a conversation between the superintendent of Cleveland Public Schools and Mark Collier concerning the city's low graduation rates, especially among young men. Collier's administration sought ways for the college to address this problem, and the resulting program has been inspiring. B-W, through its partnership with the Cleveland schools, works with a group of eighth-grade students, guiding them through high school with mentoring and summer programs at B-W. This grant-funded program is the first of its type in the country. The pilot group (pictured above) graduated in 2007; many men were the first in their family to earn a diploma, and they were all the first in their family to attend college (11 at B-W). The students are seen below with director Ladonna Norris (1990) at the Barack Obama rally in February 2007.

The four people in this photograph (from left to right, Mark Collier, Georgianna Bonds, Richard Durst, and Neal Malicky) represent over 50 years of presidential leadership, beginning with Georgianna's late husband, A. B. Bonds, in 1955. These individuals gathered for the inauguration of Durst, who said, "It was important to me that the inauguration of a new president be the celebration of the continuing legacy of a college." This legacy celebrates B-W's history in conjunction with anticipation of its projected path. The school seal embodies this heritage as well. The hands can symbolize not only Baldwin University and German Wallace College but also the bridging of past and present, male and female, black and white, rich and poor. It symbolizes that whatever has the power to divide can also have the ability to unite in a common mission; in this case, the mission is B-W's future.

BIBLIOGRAPHY

Clary, Norman J. "Baldwin-Wallace College: A Microcosm of America." In *Cradles of Conscience,* edited by John W. Oliver, James A. Hodges, and James H. O'Donnell, 39–51. Kent, OH: Kent State University Press, 2003.

Feuchter, Clyde E., et al. *A History of Baldwin University and German Wallace College.* Berea, OH: Baldwin-Wallace College, 1945.

Halberstam, David. *The Children.* New York: Random House, 1998.

Holzworth, W. F. *Men of Grit and Greatness.* Self-published, 1970.

Nichols, Bill. *And We Must Excel.* Berea, OH: Baldwin-Wallace College, 2001.

Schneider, James G. *The Navy V-12 Program: Leadership for a Lifetime.* Boston: Houghton Mifflin Company, 1987.

Sego, Mickey. *Then There Was None: A History of the Berea Sandstone Quarries.* Berea, OH: Berea Area Historical Society, 1996.

Unnewehr, Lewis E. *Silent Night, Unholy Night: The Story of German-Americans during World War I.* New York: Vantage Press, 2000.

Versaci, Bette Lou. *The Past We Inherit.* Self-published, 1974.

Webber, Judge A. R. *Life of John Baldwin, Sr. of Berea.* Caxton Press, 1925.

ACROSS AMERICA, PEOPLE ARE DISCOVERING SOMETHING WONDERFUL. *THEIR HERITAGE.*

Arcadia Publishing is the leading local history publisher in the United States. With more than 3,000 titles in print and hundreds of new titles released every year, Arcadia has extensive specialized experience chronicling the history of communities and celebrating America's hidden stories, bringing to life the people, places, and events from the past. To discover the history of other communities across the nation, please visit:

www.arcadiapublishing.com

Customized search tools allow you to find regional history books about the town where you grew up, the cities where your friends and family live, the town where your parents met, or even that retirement spot you've been dreaming about.